COLOR

CREATIVE PAINTING

English language edition for the United States, its territories
and dependencies, and Canada published 2005 by
Barron's Educational Series, Inc.
© Copyright of the English edition 2005 by
Barron's Educational Series, Inc.
Original title of the book in Spanish: Color

© Copyright 2004 by Parramon Ediciones, S.A. – World Rights
© Copyright 2004 authorized reproductions, VEGAP,
 Barcelona, Spain
Published by Parramon Ediciones, S.A., Barcelona, Spain

All inquiries should be addressed to:
Barron's Educational Series, Inc.
250 Wireless Boulevard
Hauppauge, NY 11788
http://www.barronseduc.com

ISBN-13: 978-0-7641-5861-2
ISBN-10: 0-7641-5861-9

Library of Congress Catalog Card Number 2004114877

Text: **Josep Asunción, Gemma Guasch**
Exercises: **Josep Asunción, Gemma Guasch**
Esther Olivé de Puig, David Sanmiguel
Photography: **Studio of Nos & Soto**

Printed in Spain
9 8 7 6 5 4 3 2 1

COLOR
CREATIVE PAINTING

Gemma Guasch
Josep Asunción

BARRON'S

Contents

Without creation there is no art, so creativity is one indispensable ingredient in painting that every painter must develop. Creativity implies risk and courage: creativity involves embracing the adventure, in search of uniqueness and innovation, a personal response. But it's pointless to plunge into the sea if we don't know how to swim, for the experience will be very short lived. Learning to paint means learning how to move in the medium of painting, which is visual language, just as learning to swim involves learning to move in the water. This book gives us the help we need as we take the plunge, for on the one hand it fosters the development of creativity, and on the other, it imparts a knowledge of the medium of pictorial language.

Verbal language is equipped with an alphabet and syntax; words and pauses impart sense to every sentence in the totality of a text. The same thing happens in a painting: pictorial language is composed of elements that make sense in a composition, just as in verbal language. The alphabet of painting is made up of color, form, space, and line. The first three elements are closely related to the image, and the last one with the physics of the painting. If we once again draw a comparison to verbal language, color, form, and space are the words, the pauses, and the expressions or sentences, and the line is the tone of voice, the speed of delivery, and the emotional charge of the person speaking.

It would be absurd to try to study each of these four elements in complete isolation from the others, since the four are interrelated just like the words, pauses, and intonation of an utterance. However, it is possible to focus attention on each one of them to discover fully how visual language functions and provide a creative response using that language. In this book we focus our attention on one of these elements: color. After an introduction in which we explain the theory of color in painting, we present fifteen creative projects grouped thematically by pictorial genres so you can experiment creatively with color and find your own language.

Gemma Guasch and Josep Asunción

Gemma Guasch and Josep Asunción are two visual artists who combine artistic creation with instruction in painting. Both have fine arts degrees from the University of Barcelona, and each of them has done many shows in Spain, Italy, and Germany. Since 1995 they have been working together under the name of Creart, a cultural association for collective artistic creations. Their long experience as classroom teachers in the School of Arts and Trades in the Council of Barcelona covers all the projects contained in this book.

"You paint with your brain, not with your hands."

Michelangelo,
Letter to Monsignor Aliotti,
1542

color in

Pictorial Language

Color has taken control of me. I don't need to gain control over it. I know it has appropriated me forever. This is the meaning of this happy hour. Color and I are one and the same. I am a painter."
Paul Klee,
Diary, 1914.

Color and Visual Perception

Color is not a physical property of shapes but rather a phenomenon of perception. Light on shapes is what determines the colors we perceive. Under a white light we perceive a lemon as yellow, but it appears brown in shadow and orange near a fire. As a result, we cannot assert a lemon is yellow, only that we perceive it as being yellow in color. We don't know for certain why that lemon under a white light is perceived as yellow in color and not blue or red. But even though we don't know the cause, we do know the mechanism: the lemon absorbs all the colors of the spectrum except for the one it reflects, yellow in this case; the color it reflects is the one our eyes perceive.

Isaac Newton (1643–1727) established the bases for the whole theory of color on the observation of the chromatic spectrum that's created when white light passes through a glass prism. This is the same phenomenon produced when light passes through raindrops: a rainbow. This spectrum contains all the colors in their state of greatest saturation.

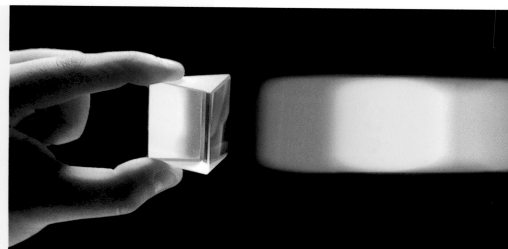

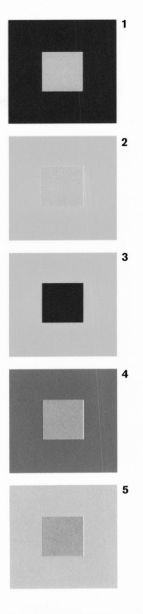

The trigger for visual perception is contrast, since without it there is no visual stimulation. Contrast is produced on two levels in a painting: chromatic and luminous. That's because in addition to its particular chromatic personality, every color has a different light value. Thus we can play with those levels to create luminous contrasts **(1)**, chromatic contrasts **(2)**, or luminous and chromatic contrasts **(3)**.

Joseph Albers (1888–1976), a painter and teacher in the prestigious Bauhaus school, conducted experiments on how colors influence one another. For example, the same gray can be perceived as slightly bluish if it is seen against a reddish orange **(4)**, or pink against a luminous blue **(5)**. This principle of color interaction is fundamental to painting; Delacroix said, "Give me mud, and I will paint the skin of a Venus . . . as long as I can paint around it whatever colors I want."

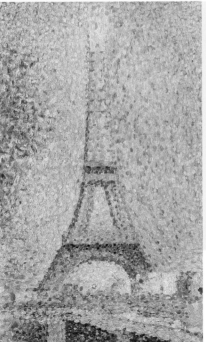

Georges-Pierre Seurat,
The Eiffel Tower, 1889. Private collection.

Bezold (1837–1907), a prestigious meteorologist from Berlin, discovered that the pure colors he distributed strategically in the carpets he made as a hobby became mixed on the spectator's retina to create new colors on the level of perception. This is the principle of optical color mixing, also referred to as "retinal mixing" or the "Bezold effect," which is what the impressionist painters, especially the pointillists such as Seurat (1859–1891), applied to their paintings.

The Color Wheel

The chromatic spectrum that appears in a rainbow or a glass prism contains all the colors of the color wheel proposed by Wilhelm Ostwald (1853–1932); we would only need to connect the colors at the two ends of the spectrum (magenta red and violet) to form the wheel. By analyzing all the colors of the spectrum we discover that three of them are absolutely pure, since they cannot be produced by any mixture; these are the three primary colors: lemon yellow, magenta red, and cyan blue. But when mixed together they produce the three secondary colors: reddish orange (magenta + yellow), green (blue + yellow), and violet (blue + magenta). If we mix a primary color with a secondary one, we get a tertiary color: reddish violet, greenish blue, orange yellow, and so forth. We could continue subdividing the wheel to produce any number of shades within the spectrum.

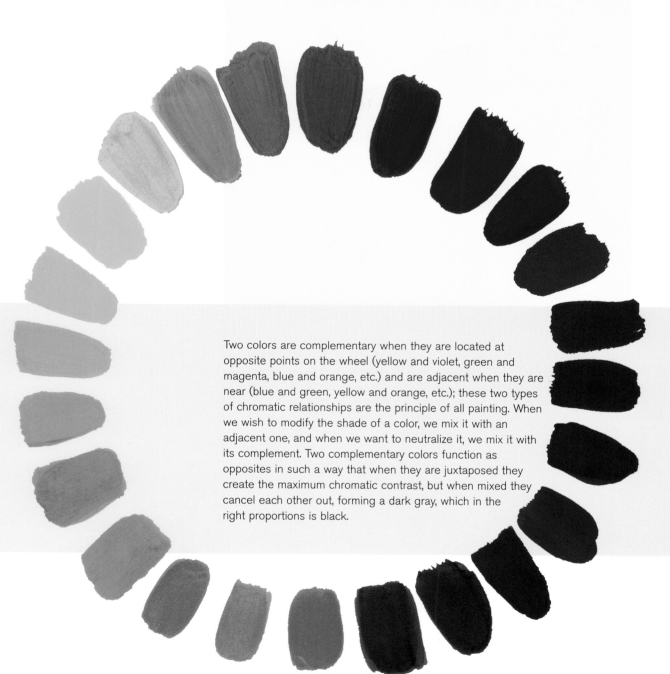

Two colors are complementary when they are located at opposite points on the wheel (yellow and violet, green and magenta, blue and orange, etc.) and are adjacent when they are near (blue and green, yellow and orange, etc.); these two types of chromatic relationships are the principle of all painting. When we wish to modify the shade of a color, we mix it with an adjacent one, and when we want to neutralize it, we mix it with its complement. Two complementary colors function as opposites in such a way that when they are juxtaposed they create the maximum chromatic contrast, but when mixed they cancel each other out, forming a dark gray, which in the right proportions is black.

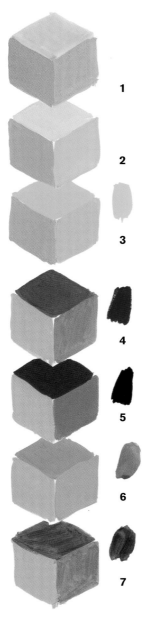

There are three ways to lighten a color: dilute it **(1)**, mix it with white **(2)**, or modify it using its most luminous adjacent color **(3)**, for example going from orange to yellow.

There are several ways to darken a color, and they produce different effects: mixing it with its complementary color **(4)**, with black **(5)**, with its darkest adjacent color **(6)**, or with umber **(7)**.

Depending on the expressive intent, the painter chooses the method to either lighten or darken a color. These methods have been used throughout the history of painting based on the desired objective, but there is no right or wrong way.

Color is defined by three factors:
- The hue, which is determined by its position on the wheel (yellowish green, magenta, purplish blue, and so forth).
- The saturation, which is the level of purity of the color. A very pure color is saturated, but if its complement is present, it is neutralized.
- The value, which indicates the level of luminosity in the color, independently of its shade and saturation (a pure yellow is always luminous, as is pink; a deep red is dark, a greenish gray can be light or dark, etc.).

Let's look at a few examples:
1- This burnt umber is an orange (hue) neutralized with its complement (saturation) and lightened with white (value).
2- This is a very luminous (value), pure (saturation) yellow (hue).
3- This is a green (hue) neutralized with its complement (saturation) and darkened in this mixture (value).
4- Cobalt blue is a slightly purplish (hue) blue; even in a pure state (saturation) it is quite dark (value).

Chromatic Harmonizations

Harmonization is the set of colors used in a painting. Harmonizing involves creating unity in the variety, which is not the same as uniformity.

There are countless ways to achieve chromatic harmonization, involving many colors in multiple combinations; but throughout the history of painting certain methods have been used repeatedly, and these have come to be recognized as classical referents. In certain periods harmonizations that tend to soften the color contrasts have been emphasized, seeking unity in a general chromatic tone that encompasses variety; these are the implosive harmonizations. At other times painters have turned to explosive harmonizations, which are based on the force of contrast and emphasize variety. In any case, harmonization seeks the active participation and the integration of all the colors in the painting, like the musical instruments in an orchestra.

Implosive Harmonizations
As the term *implosion* indicates, in this harmonization the tension is produced inwardly, by internalizing the contrast. It is based on the use of colors that are close to one another or included in a common chromatic atmosphere. The perceived effects of this harmony can include balance, uniformity, passivity, convergence, concentration, expressiveness, intimacy, and so forth. The following are the most appropriate for this purpose:

- Dominant tone harmonization: this involves a single color scale. It may be monochrome (using a single color) or melodic (a single color plus a few adjacent colors). Examples are the projects in this book that use greenish or flesh colors.

- Neutral colors: these include neutralized colors, along with their complements or whites. The examples in this book that involve neutral scales are the ones using earthy, pastelized, and dark colors.

- Thermal scales: these are based on the use of colors from the same thermal area of the color wheel: warm colors (from violet to greenish yellow) or cool colors (from green to purplish blue). This book contains an example of each scale.

Explosive Harmonizations
The term *explosion* refers to the exteriorization of the contrast, since the tension is directed outward. It is based on the use of colors that are far apart from one another, with no unifying chromatic atmosphere. The effects of these types of harmonization may include dynamism, diversity, divergence, tension, vibration, impact, dispersion, and others. The scales most commonly used for these effects are the following:

- Scales of complementary colors: this involves colors that complement one another on the color wheel; they may involve pure complementary colors (a color and its complement) or adjacent complements (a color and the one adjacent to its complement). Examples are the projects in this book involving complementary and luminous colors.

Flesh Colors,
skin tones,
modeled . . .

Earthy Colors
monochrome,
neutrals . . .

Dark Colors,
grayish,
muted . . .

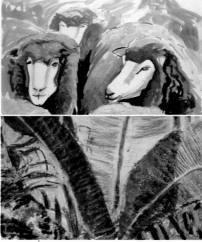

Warm Colors,
reds,
dry colors . . .

Greenish Colors,
melodic,
adjacent . . .

Pastelized Colors,
soft,
pale . . .

implosiv

- Harmonic trios and tetrads: these are created by combining the colors found in the angles of a regular geometrical figure (equilateral triangle or rectangle) drawn freely on the color wheel. The examples in the book are found in the projects involving primary colors and subjective colors.

Finally, it's appropriate to note that none of these harmonizations are exclusive of one another. A scale of muted colors can be warm at the same time, a tetrad can involve two pairs of complementary colors, a cool scale can be melodic, and so forth. There are also harmonizations very much within the limits between the implosive and explosive effects. An artist frequently works with personal scales, whether implosive or explosive, in which colors are combined freely, without necessarily conforming to a classical pattern, in accordance with a personal expressive effect. In this book examples of free scales are found in the projects involving psychedelic, worn, sweeping, and flat colors.

explosive harmonizations

harmonizations

Primary Colors, bright, active . . .

Complementary Colors, vibrant, contrasting . . .

Subjective Colors, autonomous, instinctive . . .

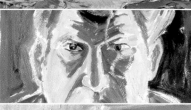

Luminous Colors, impressionistic, retinal . . .

Worn Colors, dramatic, muddy . . .

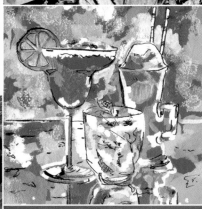

Psychedelic Colors, acid, strident . . .

Cool Colors, bluish, moist . . .

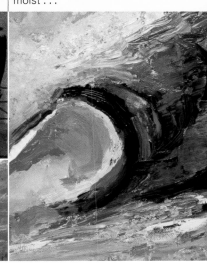

Enveloping Colors, atmospheric, spatial . . .

Flat Colors, superficial, juxtaposed . . .

Color in the Painting

Vincent van Gogh (1853–1890) is one of the major points of reference in the history of painting with respect to expression through color. In his work, colors are carefully calculated, even though they may be the product of the passion and the experience that provoke the sensations. Painting was van Gogh's life. He lived in tune with every color around him, trying to capture its essence and translate the impact it produced in him. As he explained in a letter to his brother Theo concerning the painting *Night Café*, the painter spent three nights until the wee hours of the morning inside that café soaking up every chromatic note. In it he describes the colors of the night, intense colors even though the scene is nocturnal and indoors: "Often it seems to me that the night is much more vivid and richer in color than the day," he would say in his letter. Van Gogh, like all impressionists, was tremendously interested in the colors of things, the landscape, and the person in the portrait, but he tried to go beyond that, prying out the greatest potential for expression from the local color, the color which, as he says in that same letter about *Night Café*, connects to the spectator's emotions: "It happens that it is not a locally true color from a deceptive, realistic viewpoint, but rather a color suggestive of some type of emotion involving an ardent temperament."

Chromatic schema of the painting. The impact that van Gogh achieves in this painting is due to three factors: first, the use of saturated colors; second, by harmonizing complementary colors (red and green, its pure complement, plus an adjacent complement: sulfur yellow, with a green tint), and finally, through the effect of chromatic concentration due to the arrangement of color in large areas.

"In my painting Night Café, *I have attempted to express that the café is a place where you can ruin yourself, go crazy, and commit crimes. Ultimately I have tried, by means of soft pink and blood red and wine sediment, the soft Louis XV and Verona green, contrasting with the yellow greens and the hard blue-greens, all in an infernal, ovenlike atmosphere of pale sulfur, to express something as well as the power of the darkness of a slaughterhouse. And yet, beneath an appearance of Japanese happiness and the goodness of Tartarin . . ."*
Van Gogh, letter to Theo
dated September 8, 1888

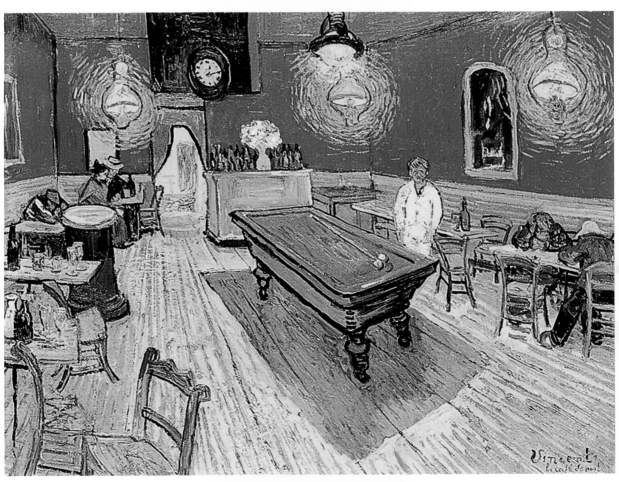

Van Gogh, *The Night Café*, 1888.
Yale University Art Gallery,
New Haven, Connecticut.

Color and Personal Expression

Numerous studies dealing with color perception show that every color produces a different effect on the observer's psyche, to the point that every culture has assigned a symbolic value to color in conjunction with that effect. Thus, for example, red is a violent color, green is relaxing, yellow is expansive, purple is depressive, and so forth. Paul Matz wrote in his article on Delacroix's *The Boat of Christ*, "I didn't know it was possible to be so terrible using blue and green." Let's see how four painters with different leanings and from different artistic periods have expressed themselves through the subjective and symbolic values of color.

William Turner, *Twilight on a Lake,* ca. 1845. Tate Gallery, London.

As a romantic painter, William Turner (1775–1851) described the struggle between nature and man, a powerful nature that surpasses human domination. In paintings such as this twilight, forms dissolve in pure light and color. A diffuse luminosity of orange hues situates the spectator at the heart of an evanescent and evocative atmosphere.

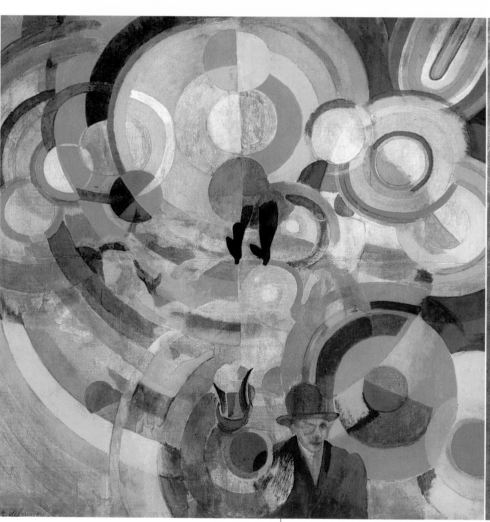

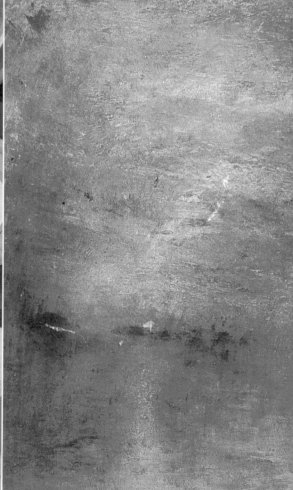

Robert Delaunay, *The Piglets' Merry-go-round,* 1922. National Museum of Modern Art, Paris.

In this painting, Robert Delaunay (1885–1941), the creator of Orphism, exploits all the dynamic potential of color, the main objective of this movement derived from cubism. A merry-go-round is an appropriate subject for treating movement through pure, active colors, in an explosive harmonization based on contrast and diversity.

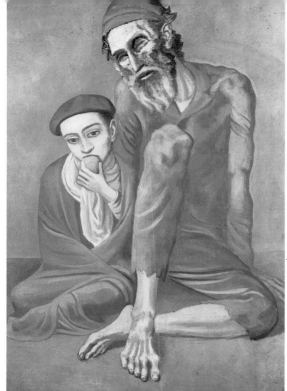

Pablo Picasso, *The Old Jew,* 1903.
Pushkin Museum, Moscow.

The blue period of Pablo Picasso
(1881–1973) is characterized by a grave
pathos in its subjects and monochrome
harmonization. The painter poured all his
tenderness and added lyricism to the
dimension of human pain and loneliness. Blue
was the perfect color for these tremendously
melancholy and beautiful monochromes.

*"Colors are the painter's material: colors in the
painter's own natural life, weeping and
laughing. Dream and happiness, warm and
sacred, like love songs and like eroticism, like
canticles and like magnificent coral. Colors are
vibrations similar to the pealing of silver bells
and sounds of bronze, announcing
happiness, passion, and love, soul,
blood, and death."*

Franz Marc

Color in Pictorial Language

Mary Heilman (born 1940) is a present-day abstract painter who is difficult to
classify. Through her work she seeks a profound relationship between surface
and color, which she articulates in a way similar to Rothko, provoking pain or
delight. In the case of an abstract color treatise, the observer receives the
chromatic impact in a pure, unadorned, sensitive experience.

Mary Heilman, *Pasolini,*
1995. Private collection.

Experimenting with Color

Of all the elements of pictorial language, color is the most specific. Color fascinates both the observer and the painter. It's difficult to find any painting in which color has little importance; color is basic even to minimalist monochromes. Many painters have turned color into the main axis of their creative work by using form as a mere excuse for experimenting with it, or by denuding the work of all figuration to plunge directly into the color with no interference.

Yves Klein (1928–1962) was a truly innovative artist who worked with color and sought its pure energy. The blue used in his works was so intense that he was soon dubbed "Blue Klein." In his series of monochromes done mainly in three colors, blue, pink, and gold, he sought surfaces on which the pigment applied in a special matte emulsion would bring the observer to a spiritual experience of ecstatic contemplation. As he said, "Feeling the soul, without explanations, without words, and representing that feeling; that is, I believe, what brought me to monochrome."

Yves Klein, *RE19,* 1958. Ludwig Museum, Cologne, Germany.

Yves Klein, *RE33, The Golden Spheres,* ca. 1960. Private collection.

Yves Klein, *RE26,* 1960. Private collection.

Edgar Degas,
Russian Dancers, 1899.
Museum of Fine Arts,
Houston.

Edgar Degas,
Russian Dancers, 1899.
Metropolitan Museum of Art,
New York.

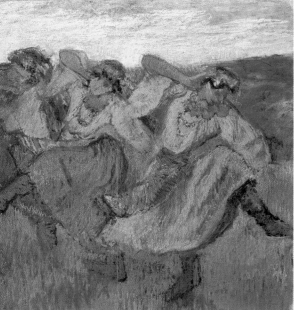

During the impressionist period, chromatic variations were very common: van Gogh's sunflowers, Cézanne's views of Santa Victoria Mountain, Monet's views of Rouen Cathedral, and Degas's ballerinas. The purpose of this type of investigation was to highlight the communicative capability of color over form. In these two versions the Russian dancers we see reproduced the "orgy of colors" that Degas mentioned. Captivated by color in movement, the artist unfolds an astounding fan of chromatic hues.

Intermittent, interlaced, interrelated . . . like the rhythms of life, the cycles of nature, and the throbbing of the heart—these are what Juan Uslé (born 1954) uses in his elegant pictorial compositions with impeccable finishes. The artist bases his images on personal urban experiences: visual impressions in motion or reflections of light. He uses non-naturalistic colors in his paintings, but they constitute great elegance in objective structures of those abstract impressions.

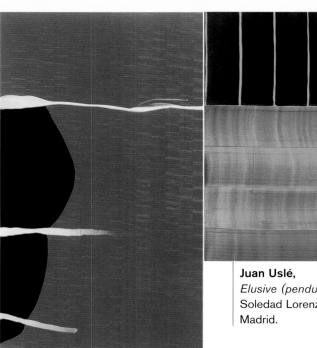

Juan Uslé,
Three Stories and a Shadow on a Red Background Ignited with Jealousy, 1995.
Private collection.

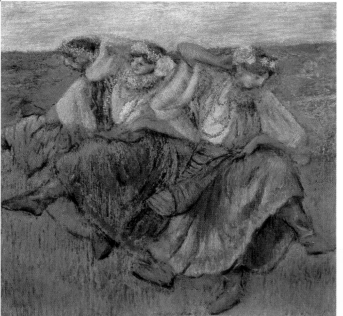

Juan Uslé,
Elusive (pendulum), 1994.
Soledad Lorenzo Gallery, Madrid.

The unfolding of colors we encounter in the natural world is tremendous. In this first chapter we focus on the color in the coats of animals and the colors of plants, and we leave other natural elements such as water and minerals for the chapter dealing with landscapes. We develop the three chromatic scales we find most frequently in nature: one involving bright, saturated color, appropriate to flowers and beautiful animals; another that is earthy and neutral, represented by furred animals whose colors blend into their surroundings like camouflage; and finally, the melodic color scale of greens that is proper to the plant world.

color in

Nature

"My enthusiasm allowed me to take all kinds of liberties. I didn't want to follow a conventional way of painting; I wanted to revolutionize customs and contemporary life—to free up nature and liberate it from the authority of the old theories and from classicism, which I hated in the same way I had hated the general and the colonel of my regiment. I was filled with neither envy nor hatred, but I felt a very strong impulse to create a new world that I had seen with my own eyes, a world that was entirely mine."
Maurice de Vlaminck

Primary, Bright, *Active Colors . . .*

Emil Nolde (1867–1956) experienced painting through its vital relationship with nature, a nature he considered to be endowed with soul. He aspired to render visible what lay beneath the surface, taking inspiration directly from the elements of pictorial language. This direct character links him formally to the group of German expressionists known as "Die Brücke," which dates from the start of the twentieth century. Watercolors were the medium par excellence for Nolde, although he also used oils to achieve this elementariness and internalization, which are transmitted through his images of great chromatic impact. Watercolor applied wet over wet on previously moistened Japan paper, with a pure and passionate chromaticism, intensifies the sensation of extreme expressiveness in his works.

Emil Nolde,
Poppies (from the catalog Watercolors 1400–1950), 1972.
Munich.

Floral Chromaticism: Pure, Vibrant Color in a Bunch of Tulips

The first project in this book is a color study on a classical theme of nature: flowers. In this project, Gemma Guasch develops a chromatic harmonization of pure colors, essentially primary ones (blue, red, and yellow), while still allowing a few secondary ones to appear (green, violet, and orange) at certain points to enrich the composition. The medium the artist has chosen is acrylic, which offers a scale of dense, flat, pure colors while at the same time allowing the application of other dry media for retouching, such as crayons and chalks. The Gallery displays some other results using these dry techniques for final touches.

"I was irresistibly attracted to the colors of flowers, and suddenly I found myself painting. I liked the haughty colors of the flowers and the purity of the colors. I liked the flowers because of their destiny: sprouting, blooming, luminous, ardent, communicating happiness, bending and fading away to end up in the ditch. Our own destiny is often of no greater consequence."

Emil Nolde,
Autobiography, Visit to Alsen Island,
Denmark, 1910.

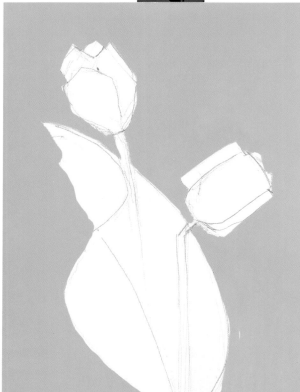

1 The first step is to lay out the two tulips in a simple, schematic way using an HB pencil. After that, we give priority to the color and define the tulips using the configuration of the background color: a pure yellow that emphasizes the autonomy of the painting with respect to the model.

2 We use watered-down paint to define the dark hues of the leaves, over which we paint the tulips in pure tones, dividing them into three unequal parts: cyan blue, green, and white.

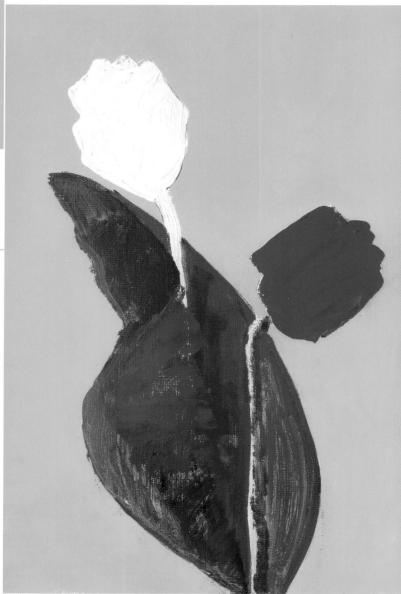

3 Using a palette knife, we apply new colors—red, yellow, and black—on the areas for the base colors. These areas contribute a doughy consistency and chromatic force through contrast.

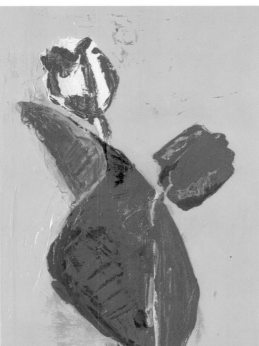

4 Next, we partially cover the red of the leaves with cyan blue to restore the initial color, but with greater richness of shades. We define the shape of the tulip on the white by using pasty lines applied with a palette knife loaded with blue paint.

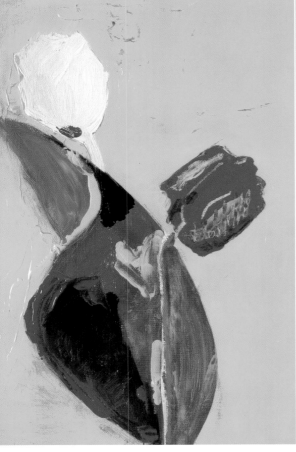

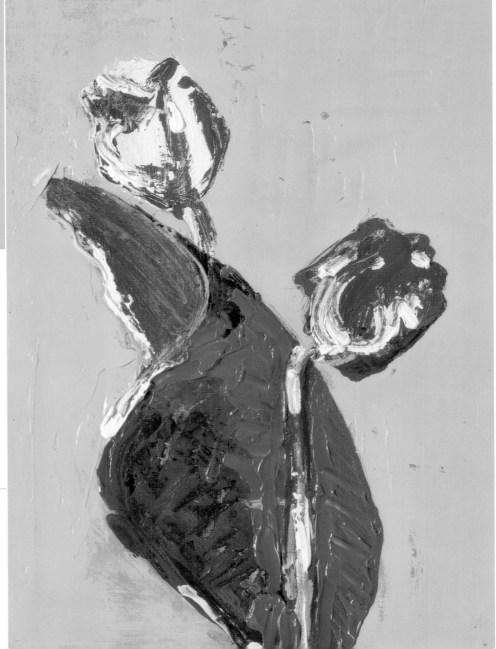

5 We finish up the work with a palette knife, applying white to recover the clean light of the subject and blue to synthesize the formal elements chromatically. The strokes with the spatula sculpt the flowers a second time and give them shape.

Other Results

By varying the distribution of bright colors in the same composition of flowers, we can create chromatic effects that are quite different, some intimate, some wild, depending on the contrast between the colors of the harmonization, as we can see in this Gallery of other possible results.

In this instance, the painter has opted for a color treatment that is less flat and more atmospheric. For that purpose she has combined acrylic paint and crayons as a technique for touching up. After painting the composition with red, yellow, violet, and green acrylics, she applied strokes of those same colors on top of the acrylic base, and she has scratched through in certain areas to reveal the base coat.

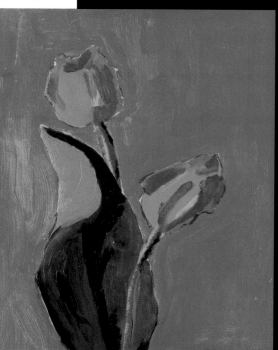

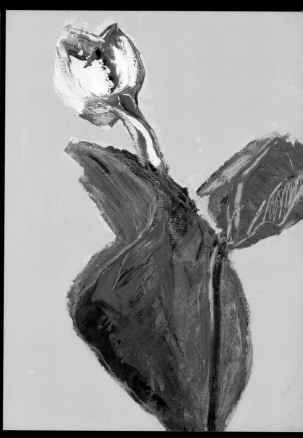

With just two primary colors, red and blue, it is possible to create a clean chromatic contrast. In this case, red is the background color, with scarcely any tonal variations, and the blue, applied with a brush, serves to sculpt the figure because it is applied in various intensities of light and shadow.

A variant of the painting developed step by step in the preceding pages, but using slightly more subdued hues, and with the paint applied less thickly. Scratching the paint in a few places while it's still wet makes it possible to see the colors of the underlying layers.

Here the artist has placed special emphasis on the vibrancy produced by the fields of color and lines. Once again, she has used crayons on top of the acrylic base and has had fun with the atmospheric effects of the shading and hatching. The greatest chromatic contrast was created by using a blue background, which is thermally cool, and a figure in reds, yellows, and violets, which are warm colors. This thermal shock adds intensity to the chromatic contrast.

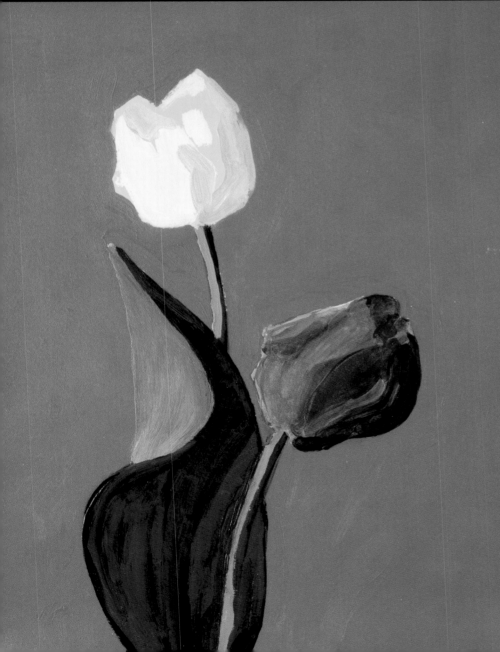

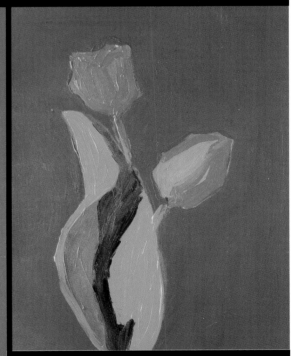

In this case the color has been applied very flat, without shading, gradations, or hatching, but rather with uniform brush strokes using direct, clean colors; the effect is a little more serious than the other results in this Gallery. The effect of seriousness has been achieved by using greens and violets that are less luminous than in the other cases.

Finally we see the vibration of the three primary colors plus a secondary one, green. The handling of light with each color gives the figure shape, breaking up the planes that are a natural result of using this pure color.

New Projects

Other Models

In nature there are many brightly colored creatures, not only in the plant world, but also in the realm of minerals, and especially of animals. Some fish, insects, butterflies, amphibians, and reptiles exhibit extremely pure colors to indicate their dangerousness or to attract mates of the same species. In this case, we have chosen a brightly colored fish to do some other paintings involving similar harmonization.

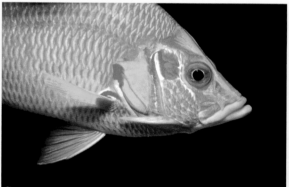

Other Media

In a dry medium, such as colored pencils, by working right on the paper, it is possible to create images quickly, with lively colors, as the artist has demonstrated in this direct sketch of the same floral theme. Work with colored pencils is enriched by varying the pressure exerted on the lines, as well as by using a varied and dynamic hatching pattern. The end result is closer to drawing than to painting because of the value of the lines and the direct nature of the strokes.

Other Views

Max Ernst (1891–1976) is considered the most important Nordic artist of our time. Ever since his adolescence he felt a fascination for discovering the disturbing and mysterious world that he intuited by contemplating nature. His contacts with Dadaism and surrealism were to leave their mark on his career, in which he sought a subversive art on a spiritual level through the unconscious. In his creations he unleashed a powerful imaginative capacity that led him to the use of various techniques, such as collage, dripping, and frottage. He was attracted to nature because of its chromatic exuberance, and he applied pure, strong, and acidic colors directly. In *Conch Flower* the use of red and white endow the painting with a forceful energy and presence.

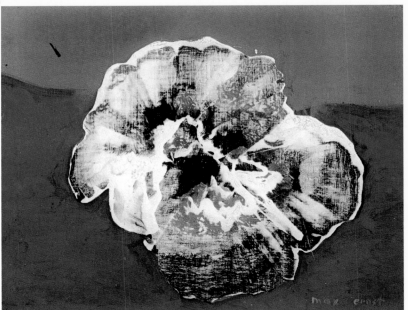

Max Ernst,
Conch Flower, 1927. Thyssen-Bornemisza Collection, Lugano, Italy.

Earthy, Monochrome, Neutral Colors . . .

Albrecht Dürer (1471–1528) was the principal representative of German Renaissance art. Skilled and richly endowed with talent ever since childhood, he was a multifaceted artist: a great engraver, illustrator, and painter. His formation was in the late gothic and the Flemish school, but soon there appeared in his work a force and an originality that pointed to a new style. He traveled to several Italian cities, including Venice, where he became strongly influenced by the Renaissance environment and art; he was also fascinated by the interpretations of the human body and the expressive force of the Italian Renaissance, which he integrated fully into his work. This evolution is clear in his watercolors; his *Hare*, for example, an extremely realistic work, is a display of how Dürer captured natural details directly. For German art his works represent the leap from the gothic to the Renaissance, a style not so much focused on idealization, but rather on the observation of all aspects of visual reality (proportion, perspective, color, form, etc.).

Albrecht Dürer,
Hare, 1502.
Albertina, Vienna.

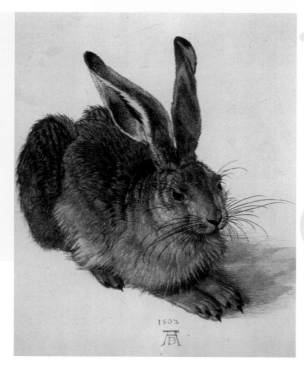

Creative Project 2

Monochrome Scales: Earth Tones in the Animal World

The animal world offers a tremendous array of chromatic scales, but one of the most common ones is the monochrome scale, usually involving neutral or earthy colors. This harmonization is based on a single color, even if accompanied by different shades, without excessive variations or contrasts, always in their appropriate spectrum. The animals that best present these scales are the mammals, with their fur or wool of uniform color, such as the ones that Esther Olivé de Puig has chosen for the following creative project: a flock of sheep. In this instance, the medium used is oils, and the selected colors are umber and sienna (burnt and raw), plus white.

"In my youth I aspired to novelty and variety . . ., in my older years I came to understand that simplicity is the ultimate goal of art."

Albrecht Dürer,
Diary.

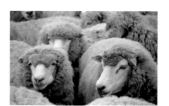

1 First of all, we lay out the painting with a drawing of the main formal features of the model. This sketch, done in freehand, dynamic pencil strokes, will help us situate the color fields, which we will sculpt to give form to the sheep.

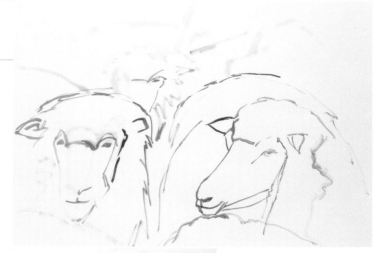

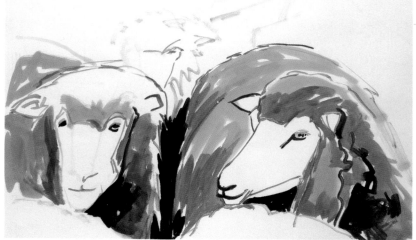

2 The primary base colors are burnt sienna and burnt umber, applied directly and highly diluted, like a wash. This technique involves lightening the color by diluting it with turpentine or essence of turpentine rather than mixing it with white paint. The resulting effect is more luminous and spontaneous, ideal for preliminary sketches and the initial colors of a painting.

3 We fill in the darker colors initially painted using the two burnt washes plus a little black, and incorporating the white in a thicker form; that way we produce a denser and more highly textured color. A few small spots of pure gray on the animals' muzzle provide a counterpoint to the warm earth tones, and at the same time they add a cooler hue that enriches the painting and communicates the soft shadows of the animal.

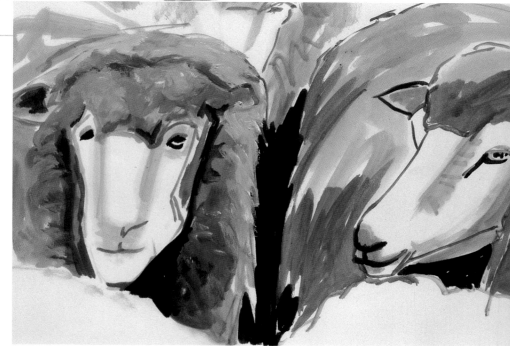

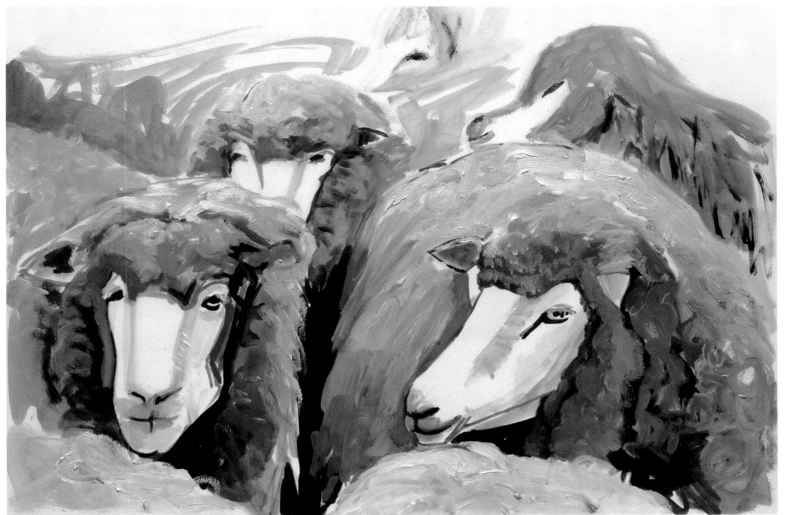

5 After defining the facial features of the animals to give the painting a sense of completeness, we apply more and denser impastos, especially white. The process of mixing thick colors directly on the surface helps provide a visual understanding of the texture of the raw wool that characterizes the sheep.

4 In this phase, the sheep's wool is taking on consistency through the impasto of denser, sculpted fields of color. Raw sienna is used, which is more yellowish than the previous earth tones, and it is applied carefully to gently shade the color scale.

Other Results

The range of earthy hues that nature offers us is very broad. There are reddish, greenish, grayish, yellowish, purplish, pinkish, orange, dark, light, and many other types of earth tones, and all these variables are part of the world of color. In this Gallery of finished works we can see how the artist has played with those variables as creative factors in color.

In this painting the main feature is the burnt sienna; mixed with white, it turns into an earthy pink, due to the reddish component of that color. For the dark hues, burnt umber was mixed with a little ultramarine blue to add gray and neutralize the warmth of the color.

The hues of this painting were obtained using raw sienna and burnt umber. The first one contributes the orange hue because of its yellowish component. The white turned the colors gray, and a small portion of blue darkened the burnt hues of the shadow, bringing them close to black.

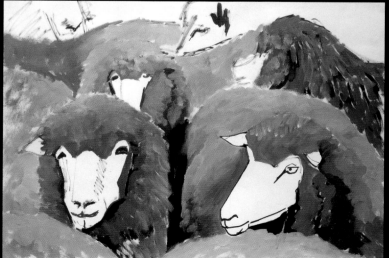

Another option is to develop greenish earth tones. On the basis of a couple of different greens (emerald and cinnabar), the artist produced some earthy colors by neutralizing them with a little burnt sienna, the reddest of them all. The raw umber is evident in certain areas, since it is greenish and dark. The white helps by adding some gray to the mixtures, and a bit of pink in the background emphasizes the greens because of their naturally complementary nature.

The painting with the most orange in this display was produced by emphasizing the raw sienna, the most yellow of the earthy colors. Yellow ochre (iron oxide) is one alternative to this color, but the raw sienna has more brown in it and is more natural in neutral color scales. Notice the play of light between the first and the last planes of the painting: the nearer plane has more gray and impasto, and the farther one is more saturated and pure, for it was created using straight colors without tinting.

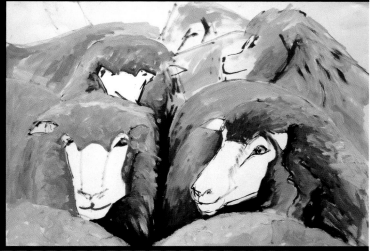

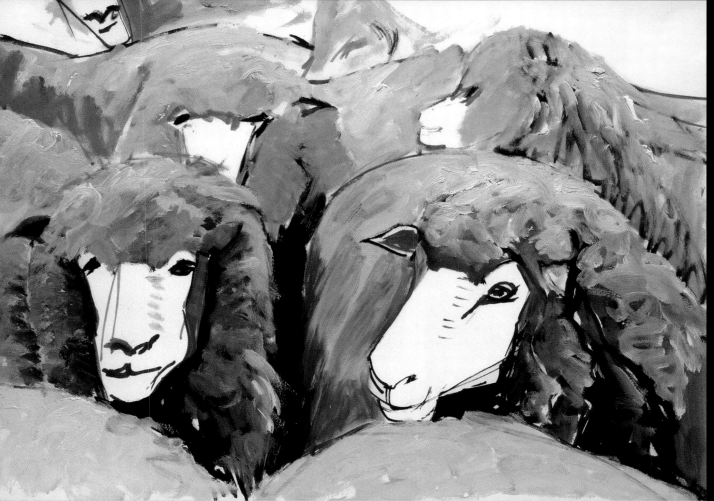

This is the painting with the most red in the display. Starting with a medium cadmium red, earthy pink grays were created by mixing raw umber, which tends toward green, with white. The principle is always the same: to neutralize the chromatic tendency of an earth tone with its complementary color: a greenish one if we are dealing with a reddish earth tone; a blue one in the case of an orange; and a purple one in the case of a yellow.

New Projects

Other Models

Among mammals there are some very striking types of fur, with remarkable contrasts, as in the case of certain wild felines. Cervids also have attractive coloration because of the subtle contrasts of chiaroscuro and the characteristic shade of their fur, like the specimens that Esther Olivé de Puig has chosen for this sketch. Using a rich interplay of warm and cool earth tones, the artist has created a chromatic dynamism involving very harmonious and expressive earth tones.

Other Media

In order to connect with the concept of simplicity that Dürer mentioned in his diary, and which is illustrated in his watercolor *Hare*, in this project the artist has chosen watercolors as an alternative medium. In contrast to oils, a greasy medium that often is applied in impastos or mixes, watercolors use the white of the paper as a point of departure and are worked in washes or glazing. Here the sheep take on a more direct and natural expression. The colors are brighter and more luminous, without losing the natural quality of the earthy color scale.

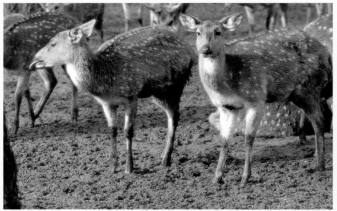

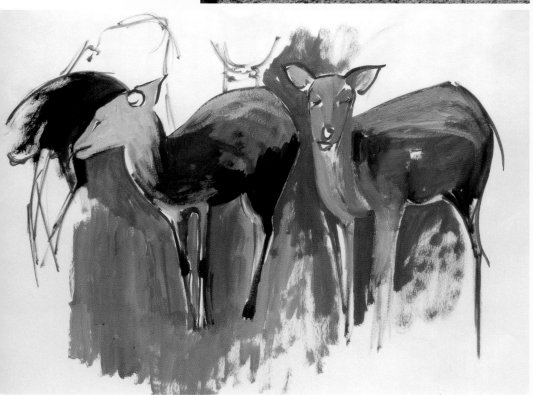

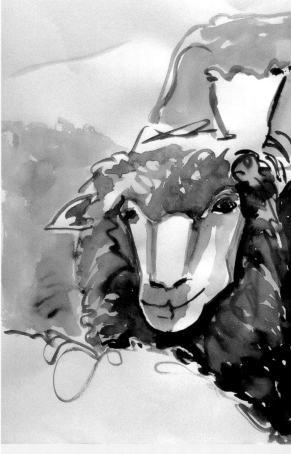

Other Views

Four centuries after Dürer, Giovanni Fattori (1825–1908) also looked at his surroundings from a realistic viewpoint. He felt a deep dissatisfaction with his work until he discovered the sensitive capacity of color fields and left the precepts of romanticism behind. In many of his canvases he shows humans and animals living together and sharing the physical and moral sufferings of daily life in a rural setting, without taking pains with aesthetic requirements. In the end he opted for impressionism, an artistic movement that for him was reduced to "contemplating a human or animal figure silhouetted against a background, whether a white wall or the transparent air." His canvases are endowed with a chromatic treatment in perfect balance between intensity and naturalness, where the earthy colors are revealed beneath a warm and melancholy light.

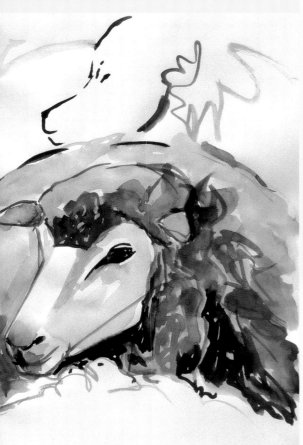

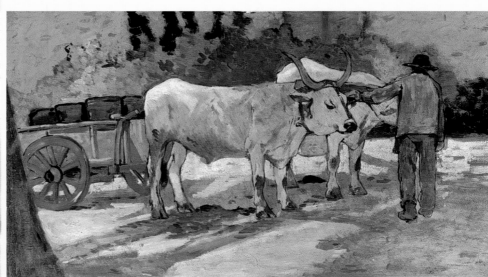

Giovanni Fattori, *Peasant and Oxcart,* 1890.
Gallery of Modern Art, Florence.

Greenish, *Melodic, Adjacent Colors . . .*

Attracted by the example of the masters of Barbizon, Auguste Renoir (1841–1919) devoted himself to painting *en plein air*. He frequented the Café Guerbois, where the artists led by Monet would gather, and he established a great friendship with them. Although he is categorized as an impressionist painter, he always questioned impressionism, asserting that "a painting is above all a product of the artist's imagination and must never be a copy"; that's why he rejected atmospheric effects and left out everything that was accidental and immediate, in search of a more elaborate finish. He used an optimistic and welcoming palette of mainly greens, pinks, and oranges. His colors mount a defense of a principle to which he always remained faithful: the painter must capture the beauty of life. He succeeded in conveying that through his canvases in spite of the terrible suffering he experienced toward the end of his life because of chronic degenerative osteoarthritis.

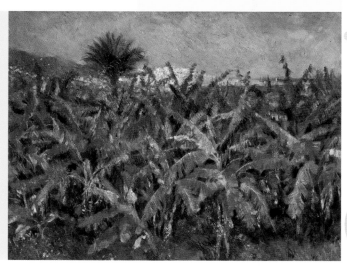

Auguste Renoir,
Banana Plantation, 1881.
The Louvre, París.

Melodic Harmonizations: Multiple Greens from the Plant World

The last project in this section on nature involves a melodic harmonization. A melodic color scale centers on a specific color by including its adjacent or neighboring colors. In this instance, the color is green, and its melodic color scale runs from bluish green to yellowish green. The color can be saturated or neutralized, luminous or dark, but always within this color spectrum. Gemma Guasch, the creator of this project, works with a plant theme very similar to the one in Renoir's painting of the banana plantation, but closer to the plant. The chosen medium is colored pencils on paper.

"I cannot copy nature in a servile manner, I must interpret it and subject it to the spirit of the painting. When I have determined the relationship among all the colors, the result must be a living harmony of colors, a harmony similar to that of a musical composition."
Henri Matisse

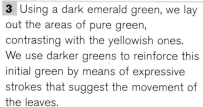

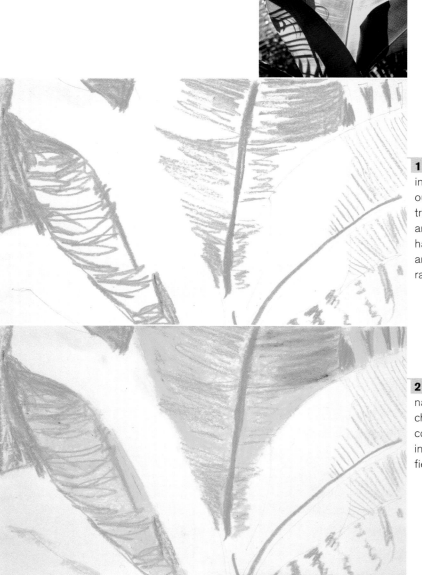

1 The initial layout of the work involves using linear strokes to lay out the large areas of color in a triangular composition. The crayons are worked to create superimposed hatching, which means the colors are mixed on the observer's retina rather than on the palette.

2 The yellowish light in this natural scene is the most intense chromatic feature, so we use this color first and add the initial lines in green to the ones in this color field.

3 Using a dark emerald green, we lay out the areas of pure green, contrasting with the yellowish ones. We use darker greens to reinforce this initial green by means of expressive strokes that suggest the movement of the leaves.

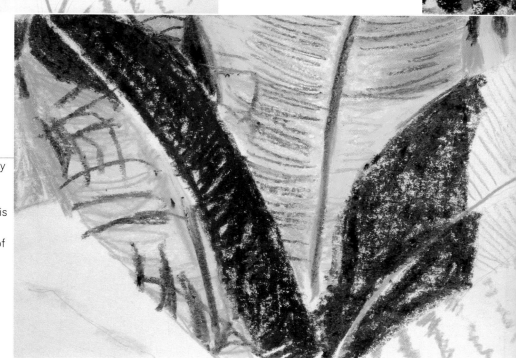

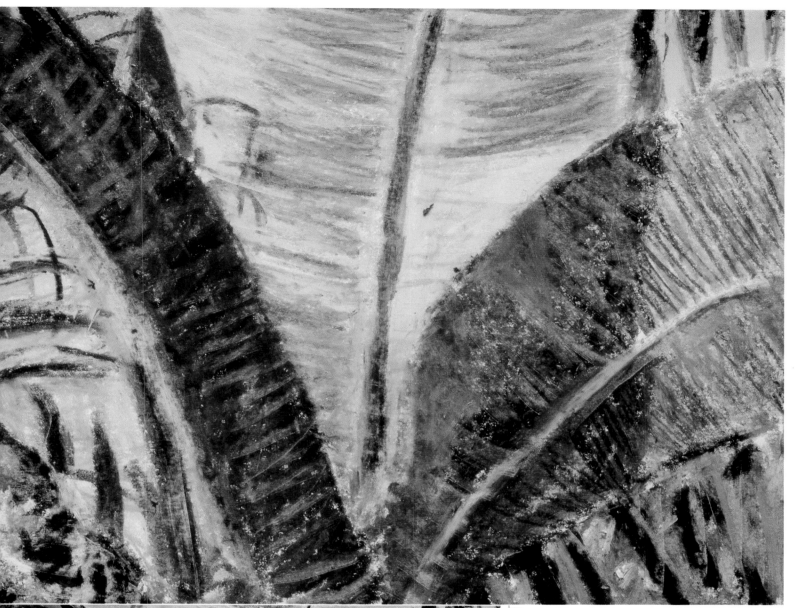

5 To finish up, we restore some luminous hues by scratching lines on the dense colored areas with a palette knife. We add hatching with white crayon which changes some areas that lack shading into pastelized greens.

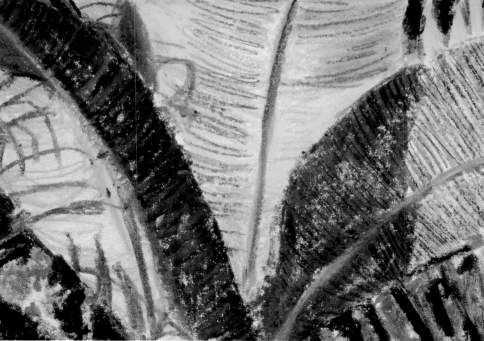

4 Next, we enrich the scale by adding lines in olive green and very dark sap green, including a little black mixed in with those greens to increase the contrast between light and shadow. Another new feature is a hatching of fine lines in luminous green on the right side of the painting.

Other Results

By mixing blue and yellow, we invariably produce green, depending on the proportions used, for this color has countless shades that run from bluish to yellowish. This process produces an infinite number of variations, since there are many shades of yellow (lemon, cadmium, ochre, India, Neapolitan, and more) and blues (cobalt, manganese, Prussian, cyan, ultramarine, etc.). In addition it is also possible to lighten any green using white, to darken it by mixing in its complementary color (red), an umber or black, and finally, to add gray by incorporating white into a dark shade. All these variables are addressed in the following Gallery.

The plant composition shown here is based on an overall yellowish green tone; there are no great contrasts in light or color, only small orange touches that appear in the dark areas of the background. The artist has respected the pure white of the paper as a touch of light to cool off the scene and represent a reflection instead of backlighting.

This image contains more blue than any other in the Gallery. A dark bluish green containing lots of Prussian blue is the chromatic axis of the painting. Fields of olive green have been added as a counterpoint; that color contains earthy yellows to create vibrations that highlight the coolness of the first green. White adds a pastel quality to the lighted areas, and black acts as deep shadow at certain points.

In this final version the artist has chosen a combination of cinnabar green and very pale bluish green to unify the scene beneath a general light. She has also added small lines in warm oranges and pinks; this pinpoint use of complementary colors is a resource commonly used to exaggerate the general note of the base color, for pure color contrast.

Here the color fields are more consistent than in other compositions. The hatching of whites and very dark greens over the general colors helps create a dense, mellow chromatic atmosphere. The direct, expressive strokes in black, white, and green provide the counterpoint in this general climate of mellow greens.

All the light in this work is concentrated in the intense yellow of the background, a color produced by backlighting the model by placing the leaf between the sun and the spectator. As in all backlighting, the contrasts are pronounced; that's why the artist has chosen very dark greens to create the shadows, shading in with sap green, emerald green, and Prussian greens.

This finished product is the softest and subtlest of all because the artist has left the white of the paper in the center and used hues softly shaded with white in other areas. With a fresh illumination and no sharp contrasts, the finish is spontaneous and misty, and the point of interest is the space created among the leaves.

Other Models

The model previously treated by Gemma Guasch conveyed its poetry through backlighting. The plant parts revealed their lights and shadows based on how the light passed through them, bathing the scene entirely in greens. In this instance, the artist has chosen a different scene: a detailed view of a plant in which a midday light falls perpendicularly onto dark, fleshy leaves and fruits with a pronounced shape. The final result combines a shaded, atmospheric background of yellowish greens with a treatment of the figure in highly contrasted greens that are cooler and applied with greater expression and decisiveness.

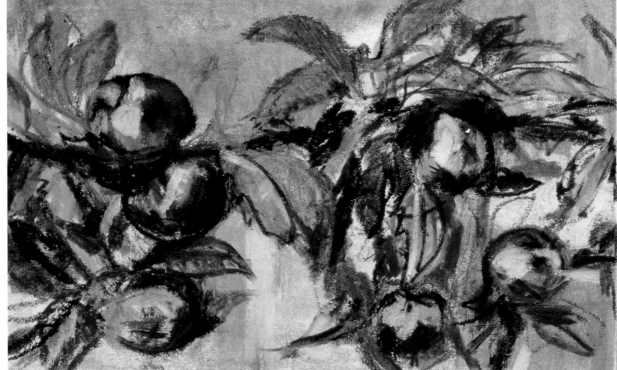

Other Media

The main characteristic of crayons is the impasto created when lines are combined on the support. Since they are applied in the form of sticks, as if we were dealing with a dry technique, the artist blends the colors on the support and in the eye of the observer (retinal color mixing). In order to experience the same phenomenon by mixing on the palette, the artist has selected gouache as an alternative medium. This is a medium that covers very well, and that trait interferes with using glazing and impastos, plus it produces flatter colors that appear opaque and velvety. The painting shown here is quite dense but also silky and soft.

Other Views

Lucien Freud (born 1922) is one of the most representative painters of contemporary realistic painting. Although his entire work is in the genre of portraiture, he has also done many paintings in which he has produced portraits of plants, seeking their emotional life, much as with humans. Freud's plants have such a real presence that it's unsettling. Look below at his painting *Two Plants*, which he painted for the cover of Lawrence Gozwing's monograph on his work, published in 1982, and of which he said that he sought to create "leaves filled with flesh."

Lucien Freud, *Two Plants,* 1977–1980. Tate Gallery, London.

The still life is the most artificial genre of all, since it involves a dramatized creation by the artist. This deliberate and intentional creation of the scene fits in perfectly with creative works using personalized, unique harmonizations. The artist can adapt the palette to the model, or vice versa, by making the model fit the palette. In this chapter we offer three forced harmonizations. The first is a scale of pastel colors produced by an excess of light in such a way that the atmosphere affects the colors with a contagious white. The second involves the exact opposite: the light is negated in the dark, giving rise to neutralized, subdued scales, and dark, tenebrous colors. Finally, we see a forced harmonization using extreme chromatic contrasts: artificial, strident, and psychedelic colors combined in an arbitrary and playful way, in a daring and adventurous creative game.

color in

the Still Life

"The sensations that colors produce in me on the palette or in the tubes, which are like little men of indifferent appearance but powerful intellect, capable of demonstrating their hidden powers when necessary, those sensations, I repeat, are pure spiritual experiences."
Wassily Kandinsky,
On the Spiritual in Art, 1911.

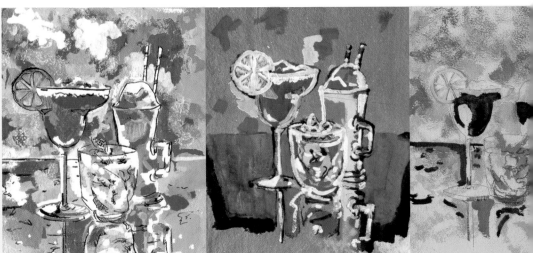

Pastelized, Soft, Pale Colors . . .

Giorgio Morandi (1890–1964) was one of the most poetic painters of the twentieth century. His work is characterized by extreme simplicity and barrenness, as well as a delicacy and beauty that make him recognizable in all museums that exhibit his work. After the First World War, he lived immersed in an inner isolation, trying to recover a world that no longer existed. He managed to create a very personal, pictorial universe endowed with great intimacy, calm, and beauty by turning to an obsessive representation of the same subjects. Despite his fame and success, Morandi lived a life of meditation, removed from travel and publicity, faithful to a line of work based on silence and austerity, with no great variation in the results. His hallmark genre is the still life: austere arrangements of bottles that reflect intimacy, pain, and solitude. Morandi's colors are always sober, but milky, pale, and pastelized in appearance. Color is never imposed; rather it allows for a delicate light that gently bathes the scene.

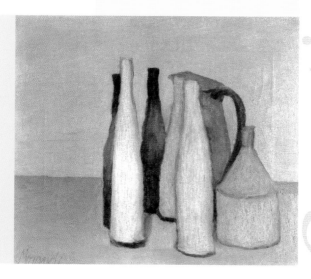

Giorgio Morandi,
Still Life, 1951.
Galleria Comunale
d'Arte Moderna,
Bologna, Italy.

Creative Project 4

The Softness of Pastel Hues: Atmospheric Still Lifes Bathed in White Light

The first project in this chapter dedicated to the still life involves experimenting with white as an active color that is capable of modifying the chromatic effect of any color by tinting it with light and softness. The concept of *pastelizing* comes from pastels, the medium we suggest for this project. Their main characteristic is that the sticks of color contain white pigment along with the agglutinant. The presence of white characterizes pastelized colors and gives them softness and luminosity. The artist in this project, Josep Asunción, has done the entire work on a coarse cotton canvas of large dimensions. The end result was fixed with lacquer to assure its permanence.

"I have emerged into the white. Swim along with me, fellow pilots, in this infinity."
Kazimir Malevich

1 Using very pale colors we lay out the composition by locating the main features: the vase, the plant, and the window. We do a pastelized harmonization using yellows, oranges, and blues by distributing these three colors in their respective areas.

2 We continue filling out the chromatic scales for each feature by incorporating new, greener blues, purples that enrich the orange hues, and more yellows and oranges. We also begin to color certain areas in white. Note how the white stands out against the rough shade of the fabric; we will play with this effect throughout the process.

3 There is no perception of light if there is no shadow, so the picture needs more contrast; a pastelized harmonization suggests that everything is pale; however, it's appropriate to create slightly darker areas to make the white stand out. Here we create the shadows by cooling them off with purples. We also darken the bunch of flowers with burnt sienna pastel.

4 Next we soften the colors in the most atmospheric areas by blending with the fingers. Blending is a technique that characterizes pastels, which offer great possibilities in this regard, since the pigments are not fixed on the support and they blend together quickly.

5 To finish up, we add some lines in multiple colors on top of the blending. We sketch in an expressive manner, creating a hatching that allows the atmosphere in the background to breathe. Here it has been necessary to use a box of pastels with a broad range of colors.

Other Results

In the previous work the artist didn't adhere to the natural colors
of the model but rather chose to add some personal color touches.
In these pages we see some further variations along the same lines
of using color creatively, still in pastelized color scales.

Yellow and blue, unmixed, are the two colors that
harmonize this work. The presence of umbers mixed
with ultramarine blue in the dark areas subtracts
chromatic energy from the picture by neutralizing it.
The yellow used is pure, as is the final sky blue, and
the two converse in an off-white atmosphere
accompanied by a couple of reddish touches that
make the scene vibrate from behind.

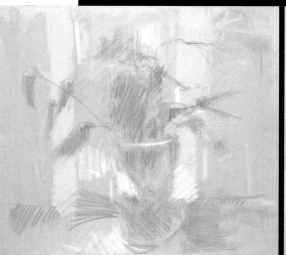

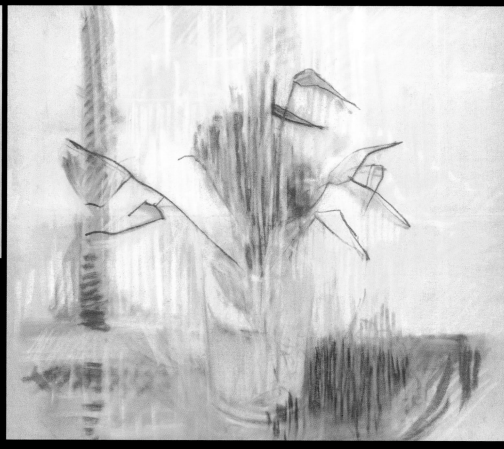

In this still life we see a
pastelized scale with hardly any
contrasts between light and
dark. The only contrast that the
artist has chosen to work with is
chromatic: greens and pinks,
both very soft and pale. A few
touches of yellow and white
enrich the light and contribute
transparency to the scene.

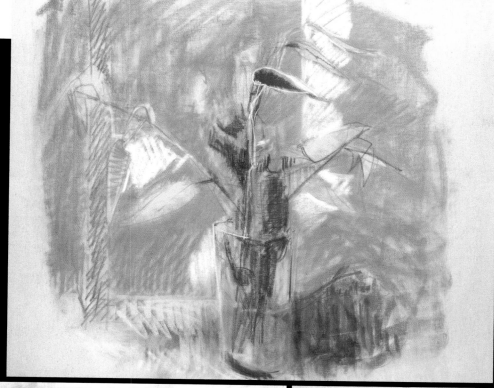

Here a warm climate has been created by means of the violet hues combined with orange umbers. In order to avoid confusing the mauve hues and the pinks, the artist has added white to communicate light and dark blues for shadows.

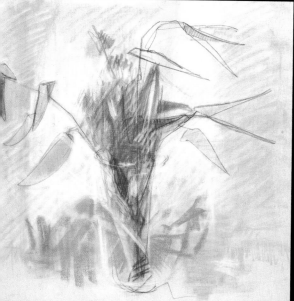

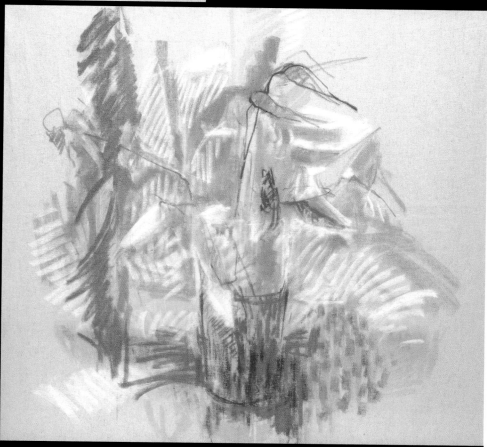

Green and red are two complementary colors that vibrate intensely but harmoniously in a color scale. In this work we witness the pacifying power of white. A few bluish or yellowish lines balance the final scale; the white that appears behind the leaves creates a sensation of gentle backlighting.

This is the most divergent treatment in the Gallery. First of all because there is scarcely any shading; the artist has annulled the soft atmospheres and paved the way for a retinal mix of colors through expressive lines. Second, pure grays are used in the chromatic scale. Gray is also a pastel color, even though it has no chromatic hue.

1 On a surface of burlap we prepare a dark background that is intentionally uneven. We first apply a layer of grayish blue, and on top of that, a second layer of bluish black using thinner paint that we cause to run vertically to create large drips. Once this background is dry we sketch out the still life with linear brush strokes in cobalt blue with some gray added.

3 We continue the work by giving shape to the skull in a pink shade using burnt umber; as it blends with the previous blues it creates a new, intermediate one that is slightly gray. We apply this color while the paint is wet, working wet over wet, so the colors blend thoroughly on the burlap.

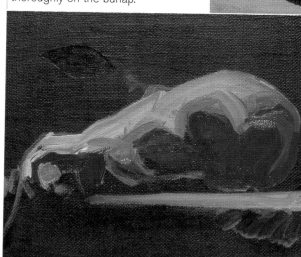

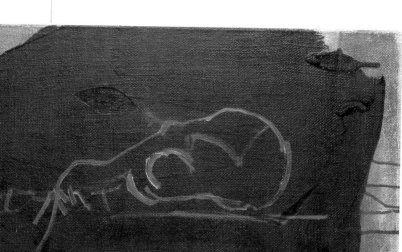

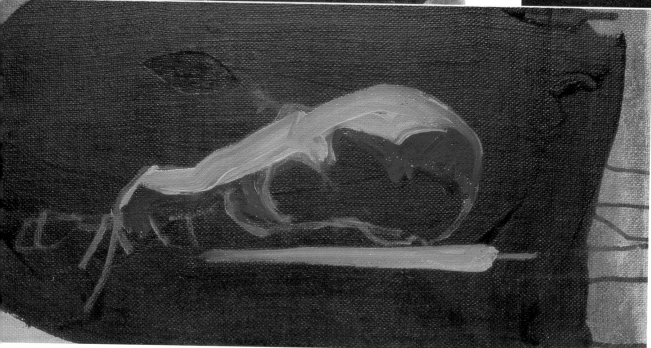

2 Using broader brush strokes we lay out the main areas of light in the still life. The entire harmonization is in blues, so we lay out the light areas using grayish blues with a little umber and lightened with white. For the intermediate shades we use slightly darkened cobalt blue.

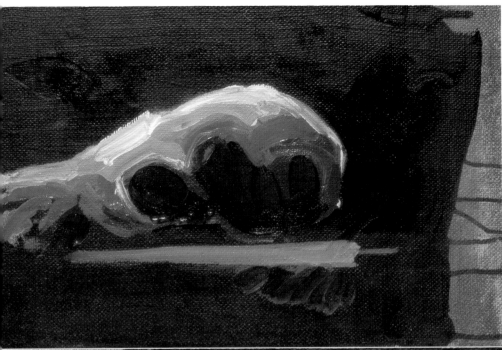

4 Next we adjust the light to exaggerate the contrast. We add light using white and darken the shadows inside the skull with bluish black, and we add a few more passes with blue over the intermediate pinks to recover the overall shade.

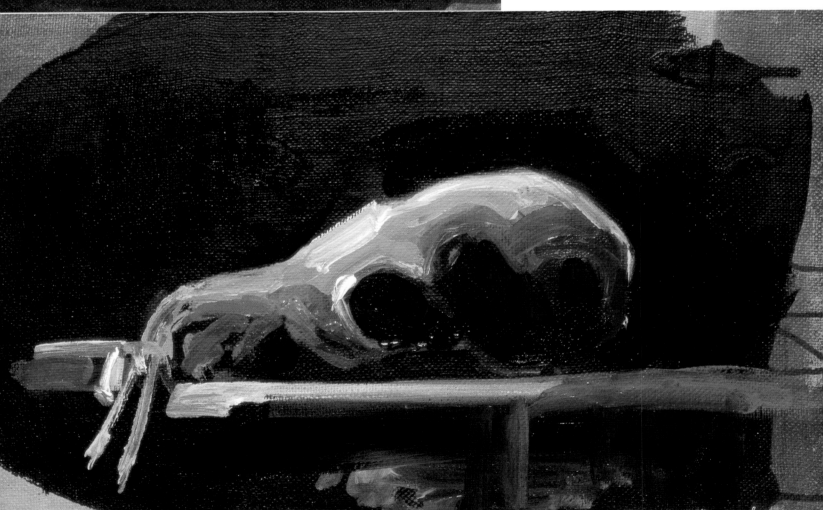

5 To finish up, we integrate the figure into the background by expanding the dark blue of the skull toward the outside, and by adding a little more definition to the table on which it rests.

Gallery

Other Results

All colors lose their natural luminousness and take on a grayish hue when they are mixed with their complementary colors. The creator of this project has used different combinations of neutralized colors to produce baroque atmospheres tinged with green, pink, blue, orange, and other colors, dense and tenebrous in all cases.

Two shades of gray are used in defining the skull in the following composition: greenish grays and pinkish grays—two complementary hues that provide a pleasant contrast when neutralized with white. The black in the background acts on a dark gray to reinforce the edges of the table.

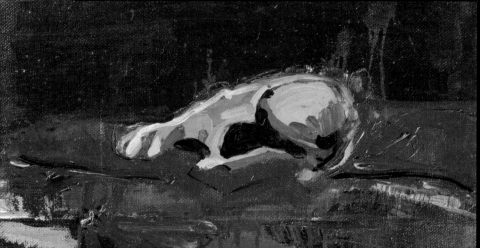

A color harmony based on brown has been established by using umbers darkened with dark purple. The whites mixed with the umbers produce pink hues with a tinge of orange. This is a classical baroque color scale.

The contrasts among colors have been intensified in this painting. Note that an intense white defines part of the skull, while letting the yellow and green hues breathe behind it, and a pinkish violet hue presents an intense chromatic counterpoint. The white applied directly also adds modernity to the tenebrism.

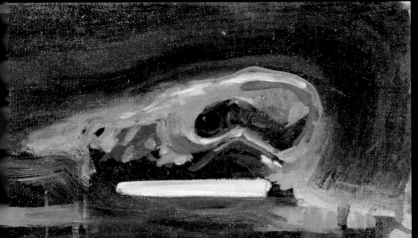

The muddy tones constitute the color scheme of this still life. The combination of fleshy tones and neutralized blues produces an unsettling dissonance of colors. Patches of blues, greens, and whites visible in the background deemphasize the overall composition and make it more contemporary.

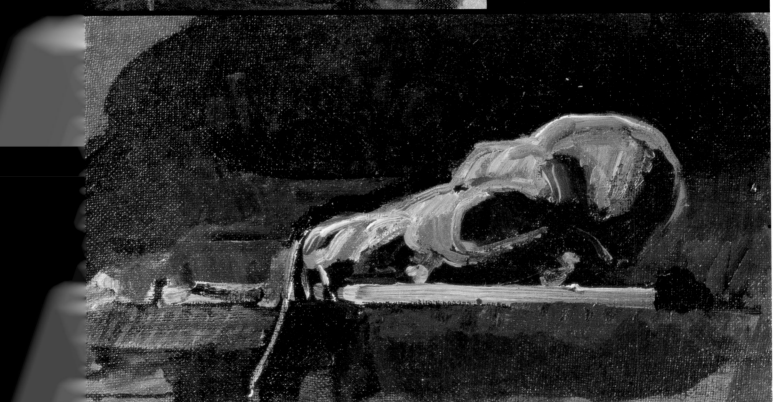

The slightly grayish green hues make for a composition of elegant harmony. The artist has joined the background and the form by using the same greenish hues, darkening them in the background and giving them more luminosity in the skull. There are some small, carefully applied touches of gray and neutralized orange that contrast gently with the whole.

New Projects

Other Models

Many baroque artists were captivated by the genre of the ordinary
still life and depicted basic kitchen implements in their works:
containers, pots, plates, and even food. In order to present a
similar model of harmonization, but using different accessories,
the artist has created a baroque scene with earthy hues and
without color contrasts. The result is a beautiful composition
framed on a purplish background with orange and umber
highlights. The colors applied with direct brush strokes provide
this painting with volume and space.

Other Media

Pastels are the perfect medium for creating
atmospheric effects; Josep Asunción has
used them in painting this alternative still
life. The colors blended by hand, as
illustrated in the photo of one stage of the
work in progress, produce a misty, spatial
effect. The colors chosen in this instance
are earthy ones, with a hard pinpoint
illumination in whites and yellows.

Other Views

Let's examine two very different views with a tenebrist complexion: one lyrical and the other dramatic. An example of the former is Anne Coster-Vallayer (1744–1818), one of the few women painters who carved out a place for herself in the history of art, even though she is unfairly hidden in the shadow of such painters as Chardin and Zurbarán, with whom she has always been compared for the magic of her tenuous light and her delicate treatment of the textures in her still-life paintings. Cézanne (1839–1906), however, approaches tenebrism in a more dramatic fashion, using strong contrasts and hard impastos of highly neutralized colors in order to highlight the shape of the objects and the real space occupied by the scene.

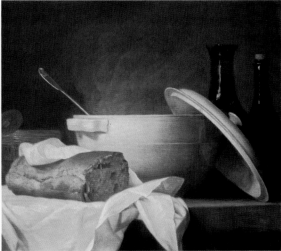

Anne Coster-Vallayer,
The White Soup Tureen.
Private collection.

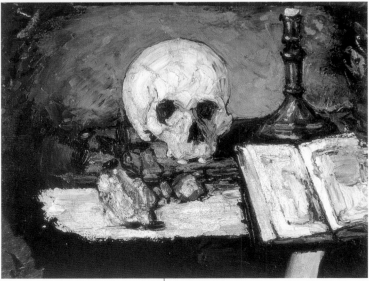

Paul Cézanne,
Skull and Candlestick, 1865–1867.
Private collection.

Psychedelic, Acid, Strident Colors . . .

Joan Miró (1893–1983) entered into surrealism through a series of still lifes with a very subjective color scheme, which years later he confessed were due to hallucinations caused by the hunger he suffered during those precarious times. His famous *Still Life with Old Shoe* is a clear representative of that phase. With Miró, the use of pure colors is one way to achieve communication without evasion, as he asserted in a 1978 interview: "The simpler the alphabet, the easier it is to read it, so during that period I worked in primary colors." But with Miró psychedelic colors are limited to the primary ones, for they also include all the colors of the rainbow in their pure state, a shocking interplay of unexpected contrasts: luminous greens and reds, yellows with blues and purples, always in the most absolute artificiality and stridency: psychedelia.

Joan Miró,
Still Life with Old Shoe, 1937.
Museum of Modern Art, New York.

A Pop Still Life: Bright, Artificial Colors in Soft Drink Glasses

Nowadays the features of a still life are frequently strident, artificial colors. Food products, kitchen accessories, tablecloths, and other objects of daily life are shown in a natural manner in factory-made color hues. A contemporary still life ought to contain these colors in the same way that a baroque still life incorporated the colors of its time: earth tones, warm light, metals, coarse cloth, clays. In creating a still life in strident colors, Gemma Guasch has chosen a very suitable model: a couple of soft drink glasses, rendered in a medium of mixed techniques that combine gouache, markers, colored chalk, and India ink in some works included in the Gallery.

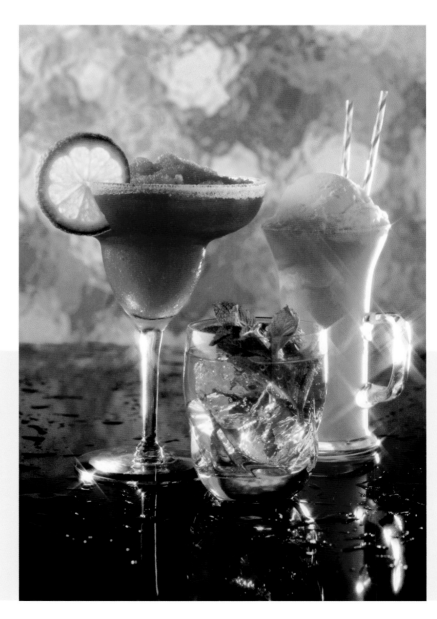

"Colors turn into dynamite charges. It was assumed that they were shooting light. It was a beautiful idea for its novelty; that everything was capable of rising up over what was real."
André Derain

1 We have chosen as a support a piece of handmade paper in two colors that make for a strange combination: pink and orange. We sketch the still life on this base using a fine-tip marker and we apply the first touches of color with cyan gouache to establish immediately a strong color contrast.

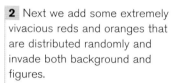

2 Next we add some extremely vivacious reds and oranges that are distributed randomly and invade both background and figures.

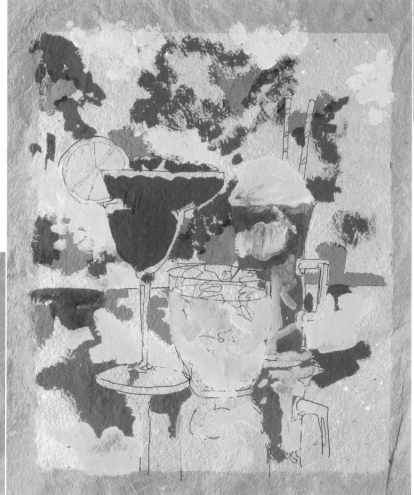

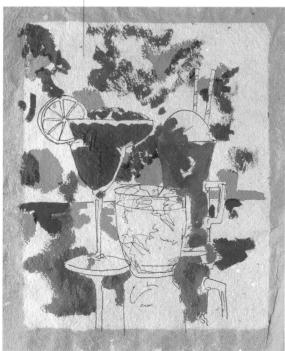

3 Using acidic yellow we complete the totality of the colors, since we now have the first three primary colors in complete vibration, thereby producing the fullest sense of replete color.

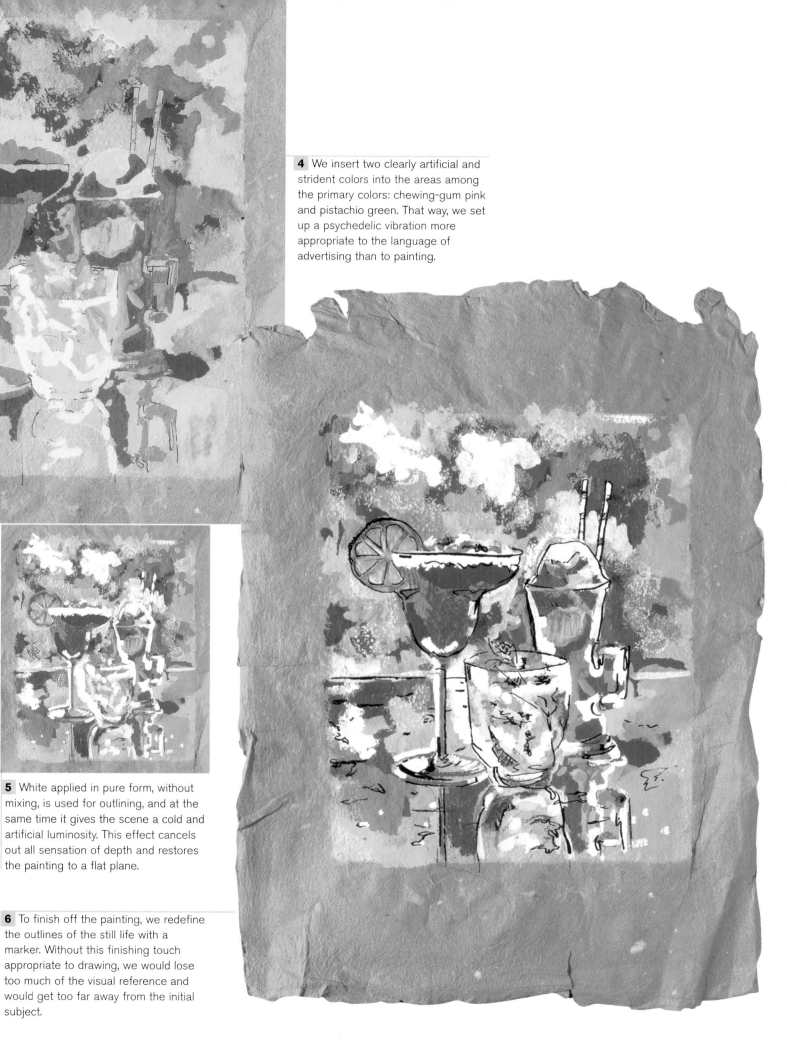

4 We insert two clearly artificial and strident colors into the areas among the primary colors: chewing-gum pink and pistachio green. That way, we set up a psychedelic vibration more appropriate to the language of advertising than to painting.

5 White applied in pure form, without mixing, is used for outlining, and at the same time it gives the scene a cold and artificial luminosity. This effect cancels out all sensation of depth and restores the painting to a flat plane.

6 To finish off the painting, we redefine the outlines of the still life with a marker. Without this finishing touch appropriate to drawing, we would lose too much of the visual reference and would get too far away from the initial subject.

Other Results

By using various combinations of color, the artist has created a rich gallery of paintings in a pop style, some more strident than others, but all harmonized in artificial color scales. The variations in the background are a major factor among the different versions, for the color assumes as much importance as the figures.

In this instance, the background is in a very artificial pale green color. The still life is crowded into the center of the paper, forming a real festival of color through superimposed patches of gouache. The final drawing was done with a black marker.

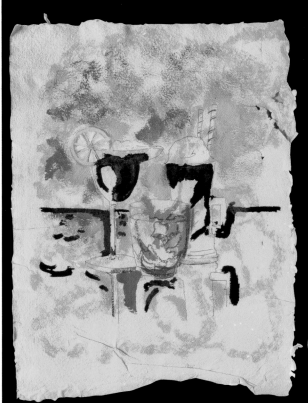

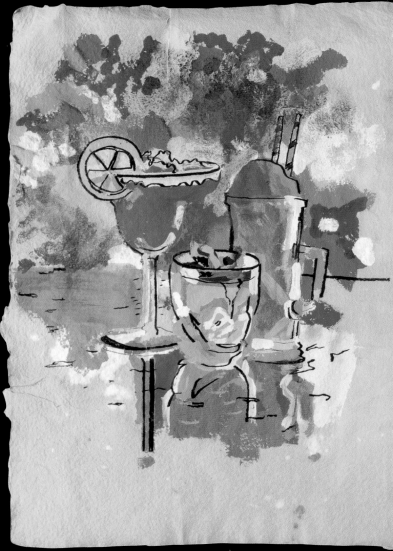

A base of yellow paper with orange chalks sets up a vibration involving green, blue, and magenta distributed in equal portions throughout the whole space. We have used India ink to outline the drawing and have created some dark color fields that contrast markedly with the light of the pure colors.

In this work the tension produced between the blue of the paper and the magenta of the figures is the moving force that activates the impact of the colors on the spectator. The blacks in the illustration were done using India ink, and the whites are gouache.

Pink, green, and yellow, slightly pastelized, are the base colors of this painting. This is a totally unconventional combination, which along with the violets and reds of the still life, constitute a bold, contemporary still-life image.

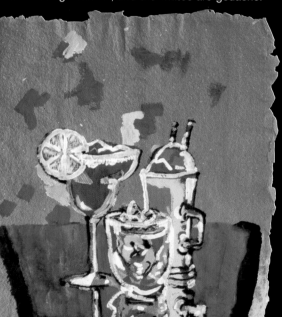

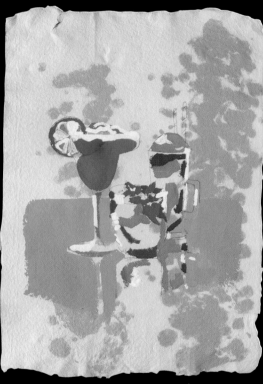

A few gouache colors distributed fairly loosely over the yellowish surface of the paper create considerable special effect as the scene loses density and body. Chalk was used to add some notes of color over the flat spots of gouache.

Other Models

A molded gelatin cake in bright colors is a perfect model for meeting the challenge of a culinary subject in pop style. The reflections from the display window caused by artificial light are one of the main reasons the artist chose this subject. The plastic resolution of this model involves bright, flat gouache colors and very artificial white areas that represent reflections.

Other Media

The same scene has been done in strokes and lines using colored markers, some of them fluorescent. Markers are a medium that characterizes other graphic languages related to painting: drawing, illustration, comics, and so forth. The end result is less dense, more transparent, and linear, more like an illustration than a painting. The background color serves as an atmospheric base for the composition.

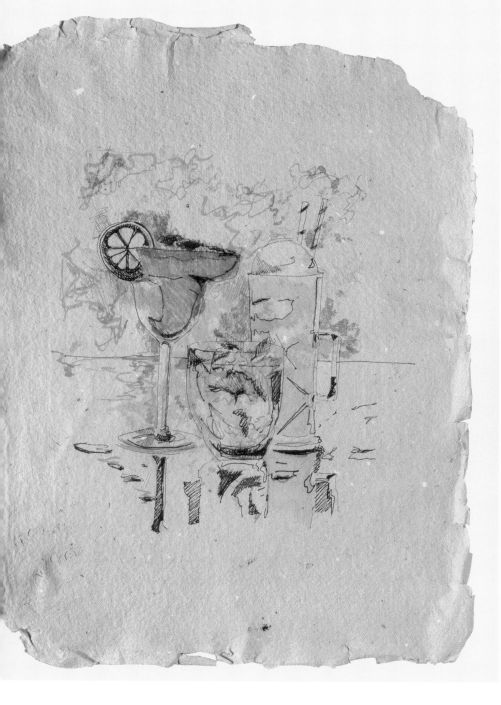

Other Views

Acidic, strident colors are appropriate to other visual languages, including graphic design, especially applied to advertising. The first artists to use such images were part of the pop art movement in the second half of the twentieth century. Andy Warhol (1928–1987) was the most representative figure of the pop art that developed in the United States. His depictions of daily objects, often commercial projects, retain the appearance of advertising images, but they are clearly perceived as artistic paintings. These are contemporary still lifes that show the implements and the products that today's men and women use, just as in other times still lifes showed similar objects in the then-current context.

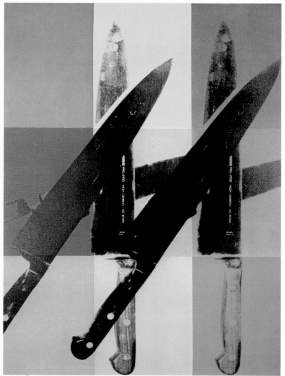

Andy Warhol,
Knives, 1982.
Private collection.

Landscape is a genre of symphonic nature in which many features of pictorial language are used, all with a single common objective: expressing the aesthetic experience of space. In this book dedicated to color, we focus on landscapes in which the chromatic factor is emphasized over the formal, the compositional, and the textural. The most common harmonizations in this genre, and the ones we present in these pages, are the thermal scales, which express an overriding warm or cool atmosphere; naturalistic harmonizations of an impressionistic nature, using bright colors that mix on the observer's retina by deploying the rich hues that create light; and finally, the harmonizations involving complementary colors, very expressive and highly contrasting, that are created naturally in the landscape at certain hours of the day and in certain seasons.

Color in

Landscape

"Rather than reproducing exactly what I have before my eyes, I use color in the most arbitrary way in order to force myself to express myself to myself."
Vincent van Gogh

Cool, Bluish, *Moist Colors . . .*

Camille Pissarro (1830–1903) was one of the most representative impressionist painters. During a trip to London, he discovered the painting of Turner, and he was fascinated by the essentiality of his landscapes, as well as by his atmospheric treatment of color. Pissarro was always interested in the poetic aspects of landscape, focusing on the visual impression and removing the concrete details from scenes to display the essentials of nature. His winter paintings are central; in them he captures perfectly the coldness of the landscape he paints. Zola said of him, in this regard, that these landscapes "can be defined as a type of austere and serious painting, a burning desire for truth and justice, a harsh and powerful will." The painting shown on this page is a clear example of those words. The painting is sincere and stark, the product of a humble, open attitude that caused him to spend long hours painting outdoors, searching for the true impression of color.

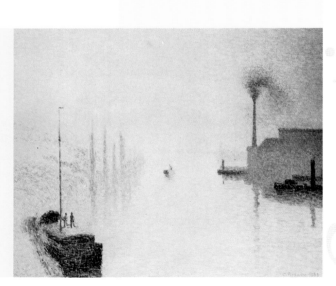

Camille Pissarro,
Lacroix Island, Rouen.
The effect of fog, 1888.
Private collection.

Blue in Motion: The Power of Ocean Waves

In this project, Gemma Guasch has chosen a seascape that shows the essence of the subject: the freshness and the power of water. In so doing, she has focused on a very special scene, the development of an ocean wave. A tremendous richness of blues are generated in the seawater through the effect of light and the density of the aqueous medium. The artist has chosen to focus on these hues through a series of representations in acrylic on a cloth-covered tablet. The essentiality of the subject presents the water in a denuded state, with no details, as Pissarro or Turner would have painted it, capturing the essential impression of color.

"Blue is the masculine principle, harsh and spiritual."
Franz Marc

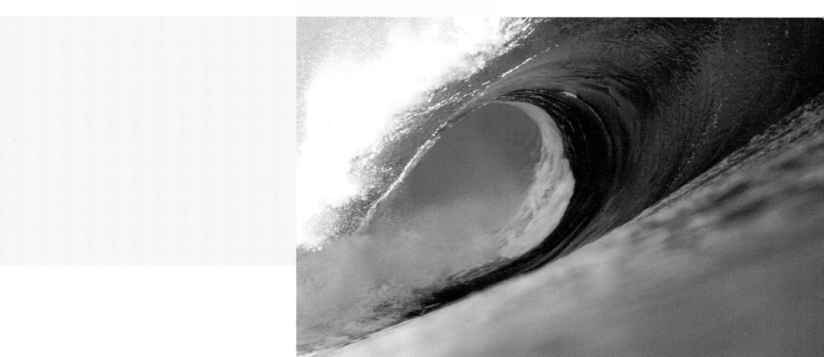

1 We have applied two hues of blue (cobalt and cyan) plus white over a background of orange and violet spots. We use planes of color to outline the skeletal form of the wave.

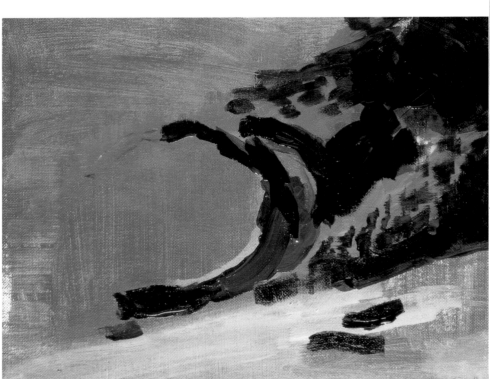

2 We use Prussian blue to color in the dark areas of the water. These blues give the sea depth and density. Even though we partially cover them up later on, they form a solid base that contributes body to the scene.

3 In this phase we add the luminous and medium blues. Once again pure cyan blue and a new, slightly greenish blue are used; the latter is made from a mixture of cyan, Prussian blue, and white. The white of the ocean foam gives the water its greatest light.

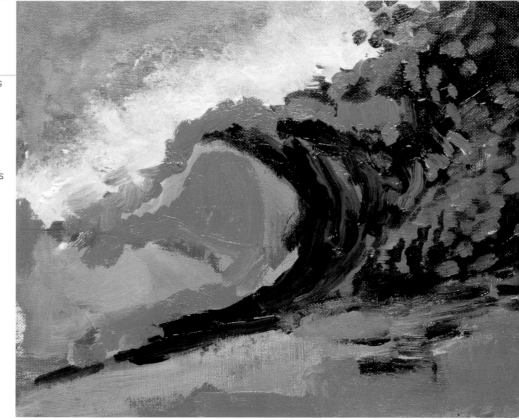

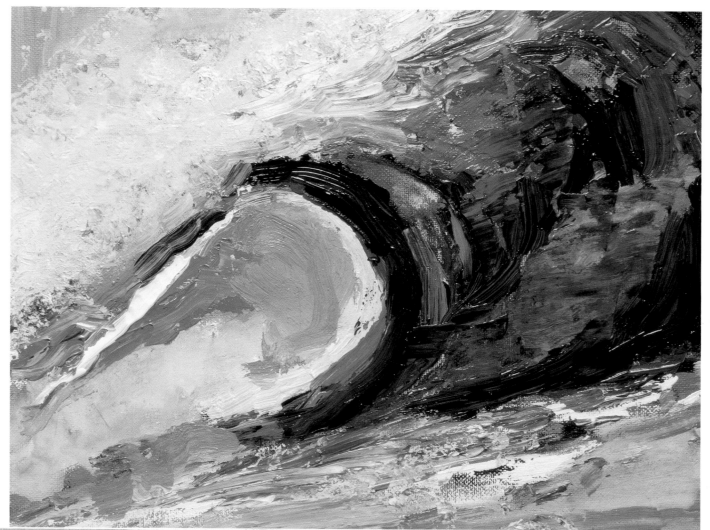

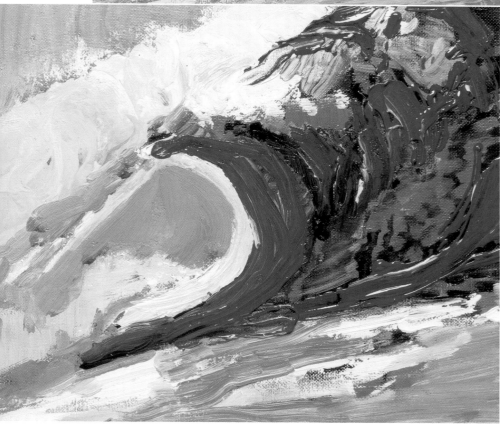

4 In order to cancel out the excessive saturation of cyan, which is the primary blue, we have slightly neutralized this hue by adding gray and some ultramarine blue on top of it. We also work with greater detail in the white foam of the crest.

5 Finally, we restore a few dark areas using Prussian blue and gray, and impasto the whites to create a softer and more misty atmosphere.

Other Results

The various hues of blue, more violet or greenish, depending on where they are located on the color wheel, can be made not only by mixing with their adjacent colors, but also by using commercially available colors containing different pigments: cobalt blue, cyan, Prussian blue, ultramarine blue, and so forth. In this Gallery, the artist has used these different hues to experiment with their visual effects.

In this painting we have highlighted the whites and soft grays of the sea foam. The end result is a spongy, luminous blue that produces a great visual impact. The ultramarine blue is the base color for the whole composition; it is the most dynamic blue because of its electric hue.

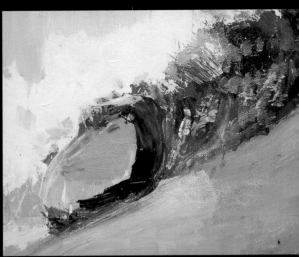

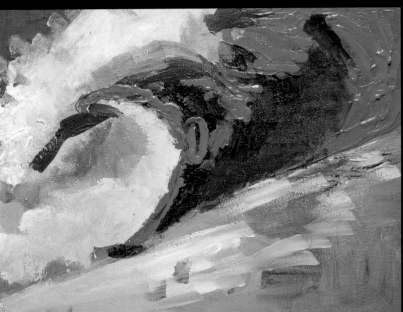

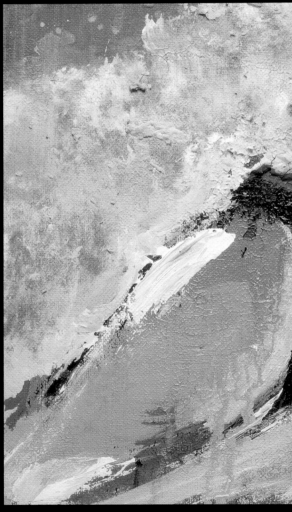

We have added brush strokes in very saturated ultramarine blue onto a harmonization in which the water is modeled through light and shadow, in the strictest chiaroscuro, in such a way that the blue vibrates because of its chromatic purity.

Prussian blue and cobalt are the two hues of this composition. The result is darker and heavier than the other paintings using ultramarine blue. The whites have also been tinted with blue, which entails a loss of light and freshness.

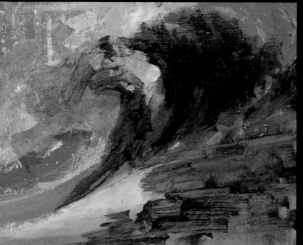

This version has a particularly marine appearance because it involves other shades of blue that approach greens, characteristic of ocean water. By applying the color in an aqueous state to produce splattering and transparent areas, we have created an impression of density that comes quite close to the reality of the subject.

This is the most elemental and daring version in the Gallery. First of all because of the use of violet as a cool color at the edge of the blues, and second, because of the frugality of the additions. A purple transferred to the support using a piece of paper with wet paint and four watery brush strokes are all it takes for this simple but beautiful image.

Other Models

The wave is a very suggestive maritime subject, but in its singular nature it is somewhat removed from the classical landscape involving water. As a result, the artist has chosen to address a more traditional scene using cool colors, and to apply all the pictorial resources of acrylic paints to a traditional landscape composition. In dealing with a landscape that offers three different spaces—water, land, and sky—it was possible to use different techniques (impasto, blending, and scraping), as well as three different types of blue (grayish, pastelized, and saturated).

Other Media

In pastels, blue is more atmospheric, ethereal, and spiritual, since it is more easily related to air, fog, and night than to water. In experimenting with such widely diverging sensations, the artist has chosen to treat the same dynamic subject in this dry, vaporous medium.

As we can see, there is a greater sense of coolness because the image is more dematerialized, but it loses the evocation of the liquid medium and comes closer to vapor than to water.

Other Views

Blue is capable of expressing many feelings, in addition to the light and coolness we have seen in this project involving a seascape. Blue is also the color of sadness, since it is passive and extremely immaterial. We need only remember Picasso's blue period to appreciate its power to dampen the spirit or study attentively the painting *The Evil Mothers* by Giovanni Segantini (1858–1899) in order to soak up the sadness of an allegorical landscape in blue, in which color becomes an absence of light and turns into death and despair. Segantini succeeded in applying light and color in his landscapes so that nature connects with the deepest of human emotions.

Giovanni Segantini,
The Evil Mothers, 1896–1897.
Kunsthaus, Zurich, Switzerland.

Warm, Reddish, Dry Colors . . .

Like van Gogh and Cézanne, Paul Gauguin (1848–1903), a post impressionist French painter, developed a highly personalized body of works by freeing himself from the dogma preached by the artists' collectives of the period. His search for a pure art form led him to abandon Paris and head to the South Seas. His painting is the expression of human passions; he always evades conventionalism and logic in his rejection of civilization. Gauguin continually sought two effects through color: intensity and simplicity. In the wild and primitive cultures of the South Seas, he discovered the people he termed "children of nature" or the "not yet corrupted," people who lived from day to day in the state of peace and happiness he was looking for. In his works, the colors of the people and the landscapes are always warm and vital, and they are applied in large richly contrasting areas that suggest the power of the primitive.

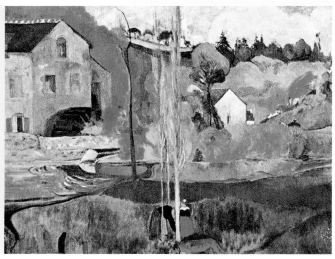

Paul Gauguin,
David's Mill in Pont-Aven, 1894.
Musée d'Orsay, París.

Warm Light in Landscape: Dusk in the Desert

During sunrise and sunset the sky commonly takes on truly fascinating chromatic hues: reds, violets, pinks, oranges, yellows, and more. These are warm colors that communicate the sun, the source of light and warmth that makes life possible. Even though warm chromatic harmonizations are often used in all genres, we have chosen landscape to do a work using this scale, since it is the most environmental and sweeping one of all. Josep Asunción begins with a desert nightfall scene to do a series of works in small format; the medium is wax sticks on colored card stock. Recall that in the color wheel the warm colors run from violet to greenish yellow, by way of red.

"In the indicated place I saw a yellow sea, some rudimentary purplish oxen, pink trees, blue rocks. . . . What things could nature teach to those talented people who reconstruct it but don't observe it?"
Mirbau,
article in *Le Figaro* about Gauguin, 1891.

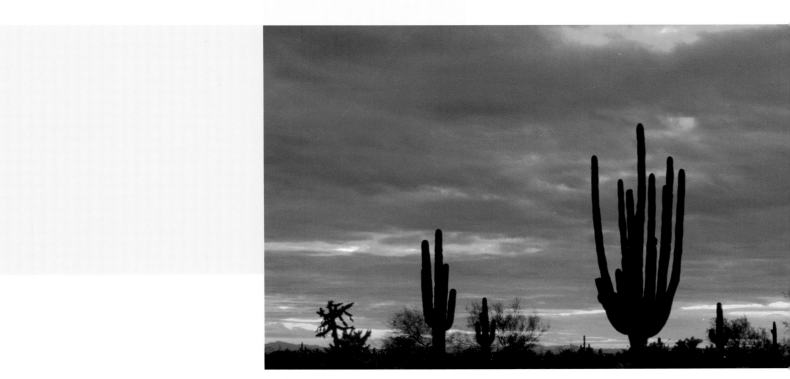

1 We start with a red background to provide the work with chromatic unity and use this background as a color integrated into the composition. Red is the warmest color in existence, and it sets up the overall tone of the painting. The first lines set up the features of the landscape on the paper.

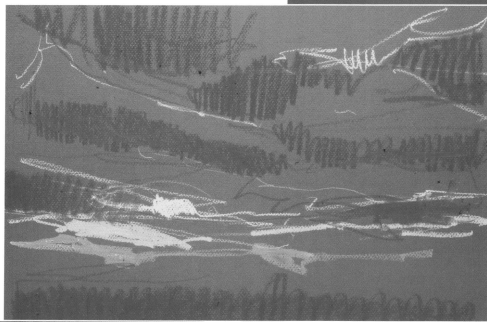

2 The real subject of this landscape is the sky, with its light and its dark, warm hues. We are going to interpret the color rather than reproduce it faithfully, so we will exaggerate the reddish tone, even though the actual scene is more purple. This second series of lines creates areas of reds of differing intensities in the sky and the earth.

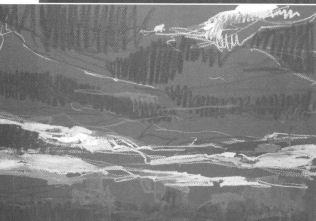

3 Next we accentuate the light by means of hatching with white and yellow in the upper and lower areas of the sky.

4 The next step involves defining all the features of the landscape, especially the cacti and the bushes. We also continue working on the sky, intensifying the colors through superimposed layers of crosshatching in dark and earthy reds.

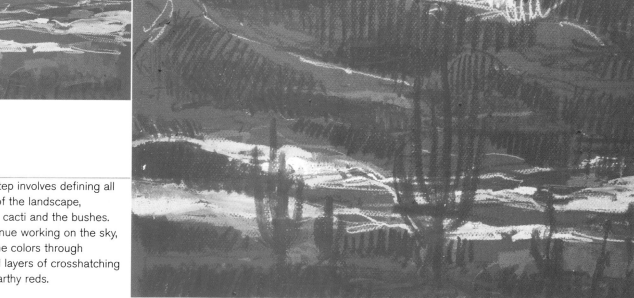

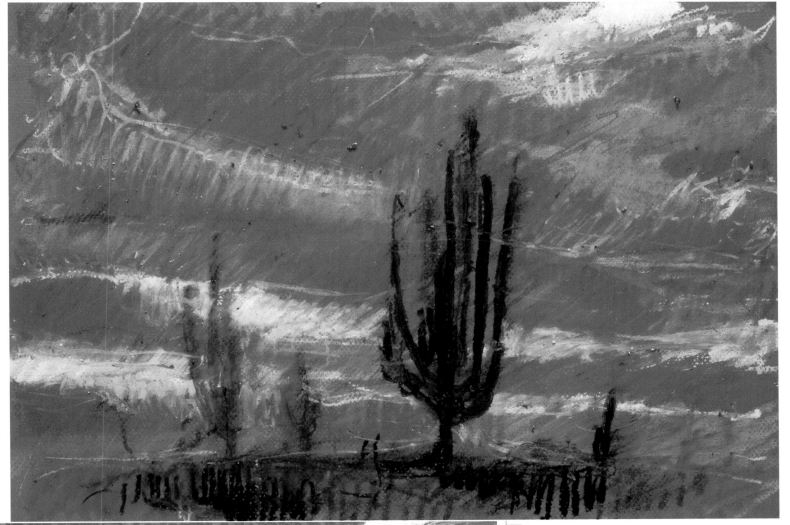

6 To create a more misty and suggestive chromatic sensation, we complete the work by applying a final color over the whole composition in a hatching of fairly orange reds that invade even the plant formations in a dense, warm atmosphere.

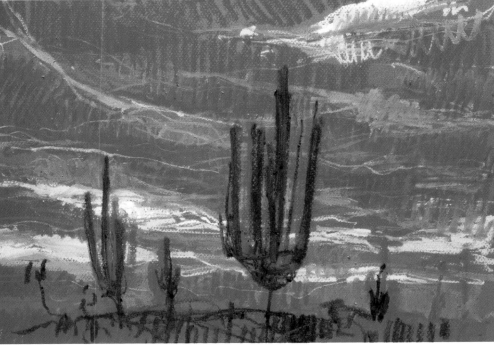

5 We darken the plants in order to reinforce the light from the sky and create backlighting. We also add superimposed purple hatching all over the sky.

Even though red is the warm color par excellence, a warm color scale still has room for lots of other hues, including a cool color that appears at a specific point to exaggerate the warmth of the overall tableau. In the following pages we see some of the artist's other ideas.

This composition is based on the interplay between light and dark set up by the yellow and the black. Black contributes more dynamism to a work than any other color. The scraping and blending with crayons and a palette knife reinforce this expressionistic character.

This painting features a yellowish green and a gray on top of the reddish background. Here the gray acts as a cool color, and it produces an interesting thermal shock that reminds us that the overall hue of the work is warm rather than cool.

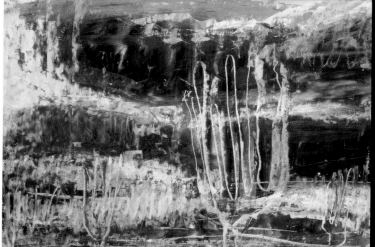

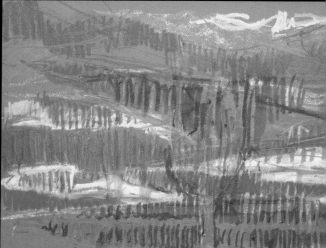

This work shows a more luminous, warm harmonization than that of the other works in the Gallery, because of the extensive use of yellow. The other colors are softer, without excessive shadow, which keeps the work from becoming too dramatic, with a view to optimizing the visual impact.

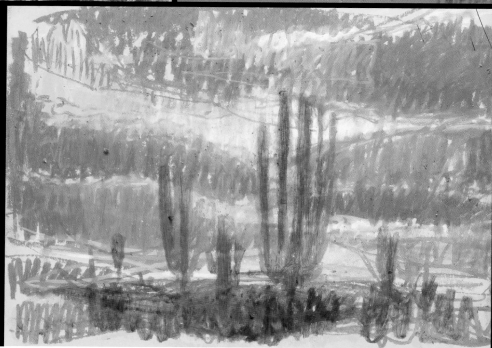

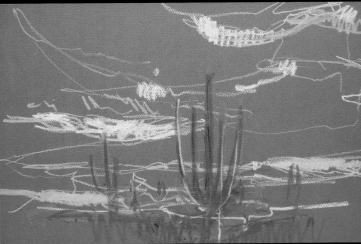

This is the simplest, cleanest, and most basic of the paintings in the Gallery. Lines have been drawn on the dark red paper to communicate the essential features of the landscape and to set up the general lighting and the compositional elements.

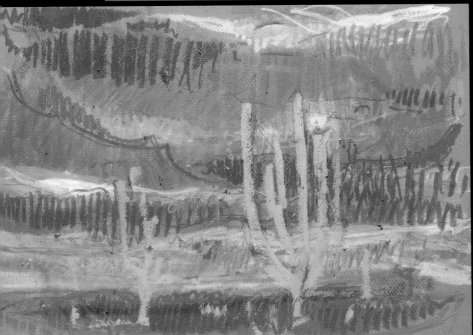

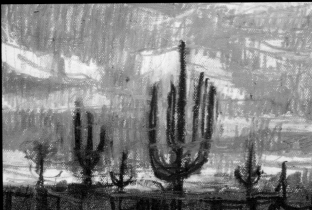

The warm effect of the sky was created with contrasting stripes in purple, white, and red. The absence of yellows slightly cools the image; white, which is neutral, also cools off a landscape. In this work the cactus takes on a powerful presence because of the size of the black shape that contrasts with the pure hues behind it.

Warm grays and dark reds with yellowish counterpoints that interact dynamically with the purple of the paper have been added over a pink background with a purple tone. In this instance, the cacti are light in color, which cancels out the effect of backlighting and reduces the brightness of the sky, making it dense and heavy.

Other Models

In order to vary the warm scale, the artist has chosen another classical scene from landscape: a sunset at sea. The presence of the water contributes a new effect of light: the reflections. The dominant color here is the orange yellow, which invites experimentation in that sector of the color wheel, as the author has done in these two works.

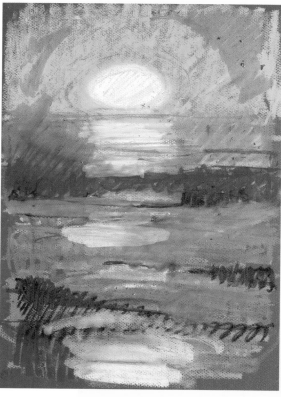

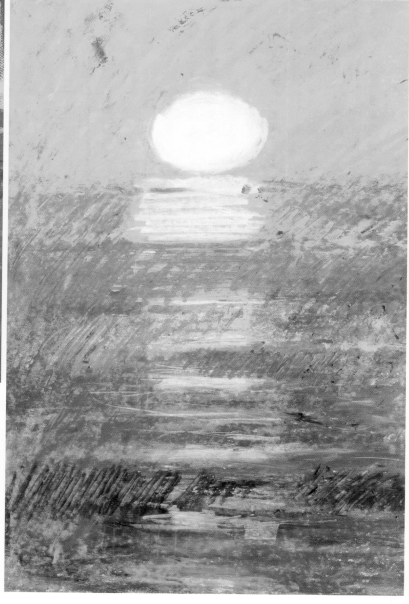

Other Media

Wax is a greasy medium worked in linear form using expressive strokes and superimposed shading. In order to vary the medium and deal with color treatments by using various techniques, we have opted for a combination of art inks and gouache, two watery mediums. Inks make it possible to create extraordinary effects of glazing because of their transparency, and gouache, which is used to cover certain areas, provides the yellow light in the sky.

Other Views

Warm harmonizations tend to produce two effects on the observer: a strong visual impact and an enveloping sensation. Both effects are related to the main characteristics of the sun: light and warmth. For romantic painters such as Aivázovski (1817–1900), the impact is the main purpose of the painting. In the example we show of this extraordinary seascape painter, the warm light unleashes a powerful explosion in a moving maritime scene where the ocean seems to be burning up. For Cézanne, in contrast, warm colors produce an atmosphere that surround the observer in a welcoming, natural environment, with no idealism or theatricality of any kind.

Iván Aivázovski,
Ninth Wave, 1850.
Russian Museum, St. Petersburg.

Paul Cézanne,
Trees.
National Gallery of Scotland,
Edinburgh.

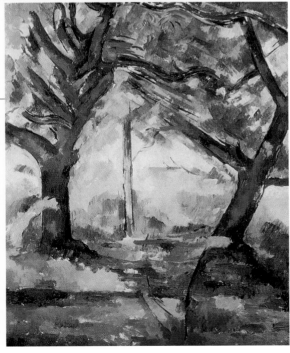

Luminous, Impressionistic, Retinal Colors . . .

Within the impressionist movement, which brought painting into the open air for the purpose of capturing the emotional impression the landscape produced in the painter, we meet Georges-Pierre Seurat (1859–1891). From the time of his youth, Seurat was infected with the scientific spirit of his age, and he applied it to his artwork. He became interested in optical color theories and the study of the law of simultaneous contrasts among colors. He noted how the action of light modifies the areas it illuminates and how colors interact with one another, giving rise to their complementary colors. He applied this phenomenon of perception to his paintings, along with optical or retinal color fusion, which is the guiding principle of pointillism. When colors are mixed on the palette, they tend toward black; but if pure hues of colors are applied in small brush strokes on the canvas, they fuse in the eye and are expressed in their purest luminosity.

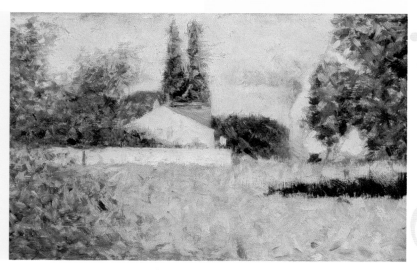

Georges-Pierre Seurat,
House Among the Trees, 1883. Art Gallery
and Museum, Glasgow.

Optical Color Mixing: The Impressionist Treatment of Light and Color in Landscape

The dual foci of this project by Josep Asunción will be the two scientific principles that Seurat applied to his work: simultaneous contrast and retinal color mixing to find what he referred to as "the art of harmony." Starting with a landscape bathed in diaphanous light, the artist does various studies of light and color in the impressionist style—however, not with a natural landscape, but rather by imagining the color scales at different times of the day. In all cases we find complementary colors in areas of shadow, and the artist uses free brush strokes of active, clean colors that mix with one another at the optical level rather than on the palette. The medium used is the most common one among impressionists: oils. Here they are brushed on to the canvas in a way that's simultaneously uninhibited and precise.

"The use of technical elements such as color, line, and tone must be subjected to careful and scientific calculations. However, the impressions that the overall work of art (line, tone, color . . .) produces on the sensitivity of the observer are not subject to calculation."
Georges-Pierre Seurat

1 The first step is to draw the structure of the landscape. In so doing we use the brush to make lines right on the blank canvas. We take the opportunity to set up the general chromatic tone of the painting, since the orange color of these initial brush strokes will remain present throughout the process. A different option would have been to do the sketch in purplish blue, another predominant color in the landscape.

3 In order to force the impression of light in the landscape, as befits a sunset like the one we are creating, we place some very dark blue tones in two areas: in the water, which reflects the night that is appearing behind us, and on the horizon, which is darkening against the illumination produced by the low light in the last hours of the day.

2 The first areas of color are the large surfaces in this landscape: sky and water. We decided to use orange for the sky (the source of light) and purplish blue for the water (the recipient of the light). Later on, orange hues will appear in the water, and blues in the sky, in some areas that we judiciously leave blank in order to avoid any physical mixing between the colors, which would cancel each other out because they are complementary.

4 A leaden blue produced by mixing cobalt blue and whiter Prussian blue makes up the masses of clouds that appear in the sky and are reflected in the water.

5 We finish up the work with smaller brush strokes that will cause the colors to blend on our retina. The still water perfectly reflects the sky and the windmills. We have to keep this mirror effect clearly in mind as we distribute the colors in order to create true thematic unity. If the colors remain the same in the sky and the water, it means the air is clean, the light pure, and the water calm, regardless of the colors used in these brush strokes.

Other Results

Now let's have a look at some other possible results using the same landscape, by imagining different light phenomena. Depending on the season of the year and the time of day, the light is more or less warm, and there is greater or lesser contrast in the image. Here we can take advantage of five variations, but there could be many more without forcing the issue, for many times nature unfolds true spectacles of light and color before us.

The same landscape in winter, at a similar hour, but the light is cool on a misty day. The artist has enriched the work by adding some pink and yellow touches and by forcing the overall hue of this scene toward green, a color sometimes used for skies by van Gogh and Gauguin. The ultramarine blue in the shadows produces a strong sensation of coldness.

This work re-creates a nightfall when the light h not yet declined to the point of yielding to nigh The windmill shows the lateral illumination from low sun. The orange tones, which are more yellowish than red, and the fairly clean, luminou blues create an impression of contrasting light warm afternoon.

In this version the illumination corresponds to a hot summer day. The electric blue of the dark areas produces an effect of thermal shock typical of impressionism: the heat of the sun's light is captured in contrast to the coolness of the shadows; in addition, the shadows are not perceived as the absence of light (black), but rather as another type of light (blue).

Dawn also produces warm and cool colors in perfect harmony, but without such extreme contrasts as in the waning hours of the day. This work shows those colors and the misty appearance of the dawn, produced with whites and a distribution of brush strokes to resemble particles floating on the air.

The reddish sky of this composition recalls the skies that appear in flames that foretell rain or wind. The presence of green, the complementary color of red, in the shadows and the reflection in the water adheres to the principle of simultaneous contrast that the impressionists began applying and the Fauvists developed further.

New Projects

Other Models

On several occasions Monet painted the facade of the
cathedral at Rouen; Cézanne painted Saint Victoire
Mountain, and many other painters concentrated on features
of the landscape, such as buildings, for the interplay of light
and shadow they produce. This is the subject that the artist
for this project has chosen: the facade of a building. He has
applied a color scheme similar to the one used for the
windmills to see how it changes the effect on a very
different model that is much flatter, without sky, water, or
horizon.

Other Media

In order to experiment with optical color mixing without any doughy consistency, and drawn to the natural luminosity of the hues of watercolors, Josep Asunción has chosen that medium as an alternative to oils. Watercolors are such a liquid medium that they produce glazing naturally; the colors mix on the paper, but without blending, except when they are applied wet over wet, as in a certain place in this painting.

Other Views

Pointillist painters such as Seurat were not the only ones who worked using optical color mixing. Most impressionists constructed their images using bold brush strokes, revealing colors that were no more than the light dispersed in the form of particles in the air. Both Camille Pissarro (see page 76) and Aureliana Beruete (1845–1912), two European impressionist painters trained in the Barbizon school and inspired mainly by light, created luminous scenes using tiny free brush strokes that blend the color in the eye of the observer.

Aureliana Beruete,
The Banks of the Manzanares, 1895.
Private collection.

Camille Pissarro,
February Dawn.
Kroller-Müller, Otterlo,
Netherlands.

Complementary, Dynamic, Contrasting Colors . . .

At the start of the twentieth century an artistic movement arose in Germany under the leadership of the movement known as "Die Brücke" (the Bridge), which opened the door to a new understanding of art: expressionism. One of its primary representatives was Karl Schmidt-Rottluff (1884–1976), who is noteworthy for his landscapes. Since one goal of the expressionists was to create an impression, in their harmonizations of complementary colors they chose color scales that would create a dynamic and radical visual effect. A harmonization involving complementary colors is a shock on the retina that makes the most of the power of contrasting colors; the Fauvists also understood that mechanism and applied this type of harmony in their paintings. Frank, direct expression was the way to communicate with the public and the way to express individual personality. The passionate, expressive brush strokes of Schmidt-Rottluff endow the landscape with power and energy, as if it were a living creature.

Schmidt-Rottluff,
Norwegian Landscape, 1911.
Private collection.

Maximum Color
Contrast: Complementary
Color Scales
Applied to Landscape

The last project in this chapter devoted to landscape is the most radical one. Starting with a traditional landscape done in the complementary colors red and green, Gemma Guasch does a series of works combining pairs of complementary colors: yellow and violet, red and green, purple and yellowish green, blue and orange, and others. We demonstrate the process for one of these combinations, the one involving blues and orange, because of its dynamism and luminosity. We use a mixed technique on paper: markers and artists' inks for the base and chalk for the final finish. By using this technique the artist aims to enrich graphically a composition restricted to just two colors that can produce great tension when they are combined skillfully.

"Complementary colors . . . blue and orange, a truly festive sound."
Franz Marc,
Letter to Macke, 1910.

1 We lay out the painting with a line drawing done using a black marker to indicate the large color fields in the landscape. Next, we fill in the base colors using artists' inks, beginning with a dark blue.

2 We use orange inks to paint the other areas, leaving some parts white; we'll deal with those later on, taking advantage of the light from the paper. In some areas we dilute the orange with the blue, since when we use the brush we encroach on the former color, which is still damp.

3 We let the inks dry, and then we use markers on top of the flat fields of color. We use blue to partially outline some blue areas and reserves of white, allowing the base color to appear between the lines of the shading. We use orange to repeat the same operation on orange areas, thereby giving shape to the mountains. We use black to better define the shapes and details of the landscape.

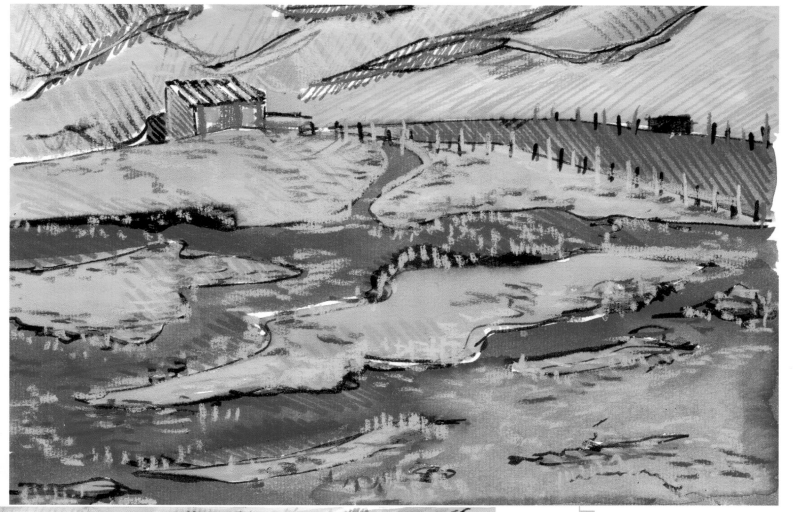

5 To finish up, we use some blue chalk on the orange areas to set up greater vibration and strength. We also add some flowers to the composition and reinforce some details such as the fence in the field, which previously was merely sketched in black.

4 Next, we use the other chalks. With the orange we add the flowers of the pasture and the reflections of the mountains, and we use blue for the walls of the house. The chalks help nuance the color by varying its tonal value.

Other Results

In the same spatial structure of the landscape the artist has combined pairs of complementary colors. Every result is noteworthy, for the vibrations also produce different effects based on the communicative capacity of each color: yellow creates visual expansion and light; orange, dynamism; blue, serenity; green, calm and naturalness; violet, closure; red, violence and heat . . .

The color scale selected here is made up by a very yellowish green and a fairly reddish violet. Both colors are tertiary ones, and they occupy opposite poles on the color wheel. Artists' inks bathe nearly the whole composition, and the result is very fresh and misty. The green is very luminous, even warm, because it contains so much yellow, and the violet appears uncommonly energetic because of its reddish component. In sum, this is a warm, welcoming contrast that is luminous and energetic.

Two more tranquil tones interact in this painting: a blue and an earth color. The earth colors really are dark orange, and that's why they turn into complements of the blue, even though they don't have 100 percent of their chromatic energy, as they would if they were pure orange. Most of this work was done with marker in a dry process and diluted with alcohol to create spongy color fields.

Here the artist has combined yellow and violet slightly shaded to soften the excessive contrast of the two in pure form. The yellow has been shaded slightly toward orange and the violet has been lightened with water. The artist has used inks, chalks, and a black marker for outlining the drawing, for the color is expressed without strong contrasts.

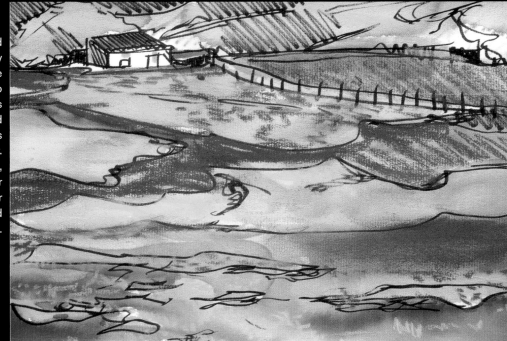

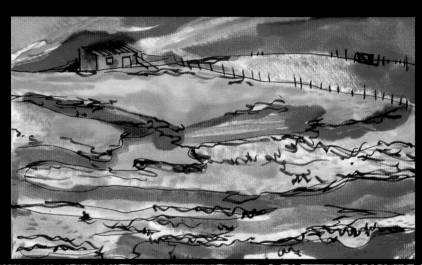

This finish is very similar to the one shown
step by step in earlier pages, but with one
important difference: the colors are
reversed: here what was orange is blue and
vice versa.

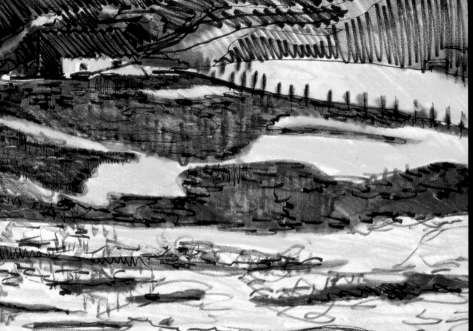

The present composition was done using
magenta and green, applying shading and lines
on top of flat, diluted planes. Both colors are
very saturated, and in the end they turn out dark.
There is a chromatic and thermal contrast, but
not a luminous one.

The dark violet and lemon yellow are the
center of attention in this work. The yellow is
very luminous; the violet ends up being dark.
A color contrast is thus added to the obvious
contrast in light.

Other Models

A forest landscape that combines greens and reds is a good alternative because of the variety of shades in both colors. Gemma Guasch has made the most of the many hues in the model, adding bluish greens and orange yellows, which turns the result into a real symphony of complementary colors.

Black adds power to the painting, since it creates deep shadows and defines the trees so the painting doesn't disintegrate into a confused image with no formal definition.

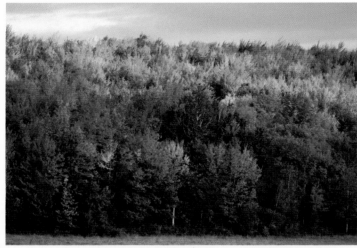

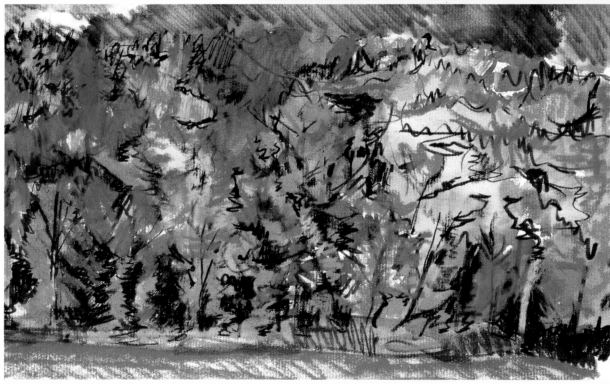

Other Media

The artist has revisited the same landscape in magenta and green, but in a different medium this time: acrylic, which is much more picturesque because of its doughy, opaque effects. She developed the image using a brush on paper. She used greens and reds of different light values, thereby broadening the chromatic spectrum of the previous compositions, which is entirely appropriate in a harmonization involving complementary colors.

Other Views

One way of proceeding with harmonizations involving complementary colors uses adjacent complements; this was experimented with intensely during the time of the impressionists. It involves setting up as a contrast to one color another one adjacent to its complement. The result is less strident, even though there is still some dynamism. This wonderful landscape by Vincent van Gogh (1853–1890) is a perfect example of this different view on the principle of complementary colors. In this painting green is combined with the color adjacent to red, its complement: orange. The works of van Gogh stand out for the purity of their colors, which the artist applied directly, searching for the inner energy he perceived experientially, beyond mere visual impression, as we read in the letters he wrote to his brother Theo.

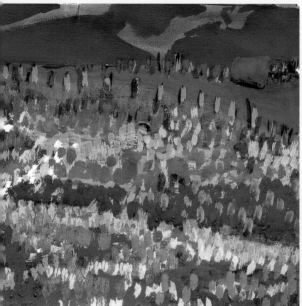

Van Gogh,
Flower Garden, 1888.
Private collection.

The color in the human figure highlights features of the person depicted and allows a glimpse of the painter's inner world. We need only recall the characters in the blue period of Picasso: blue communicates sadness and melancholy to every figure and expresses the period of sadness the artist was experiencing. There are two possible attitudes in the presence of the model: objectivity and subjectivity. The first creative project in this chapter is based in objectivity; its purpose is a search for chromatic variations in realistic flesh tones. The two projects that follow focus on interpreted and subjective color.

color in

the Human Figure

"I don't paint women, I paint pictures."
Henri Matisse,
Notes of a Painter, 1908.

Flesh Tones, Skin, Shapes . . .

Ever since he began painting, Lucien Freud, grandson of the originator of psychoanalysis, has done completely autobiographical works. Behind every painting a story reveals his life and the things around him. We deduce the quality of his relationships: with his mate, his friends, and people he knew and who influenced him in one way or another and had an impact on his life. Commonly his models were friends; as he remarked, he never asked anyone to pose for him before they struck up a friendship. His painting never fails to provoke a reaction in the observer, and it has been labeled as "shocking, violent, cruel, rotten, and affected" because of the great realism he applies to the person depicted. He explained his attitude toward the model: "There is something in a nude person when I have her in front of me that invokes respect." Freud reflects the greatness of human beings in their greatest humanity with thick, large brush strokes in flesh tones in their full spectrum of shades.

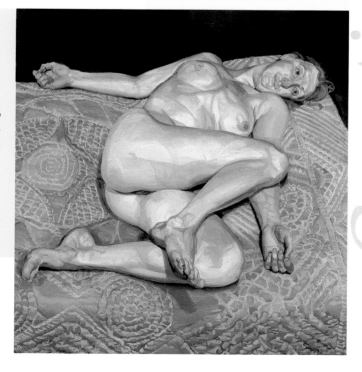

Lucien Freud,
Night Portrait, 1977–1978.
Private collection.

Flesh Tones: The Natural Tones of the Skin in Paintings of Nudes

The first project in this chapter devoted to color in the human figure is the most realistic of the three. Flesh tones are a critical topic for many painters. What color is the skin? What colors should we use to depict it? There is no single answer, since it depends on the natural skin tones of the model, on the illumination, and on the colors in the surroundings with which the skin tone interacts. Further, if we add in an open, creative attitude on the part of the artist, there are an infinite number of answers. In this instance, David Sanmiguel experiments with all possible shades of a realistic flesh tone, as Lucien Freud does in his portraits. He works the figure without achieving such an extreme finish, however. The result is more like a natural sketch, which increases the dynamism and spontaneity. The selected medium is oils because it allows for good blending and shaping with color.

"Colorists must model with color,
just as the sculptor does with clay,
marble, or stone."
Eugène Delacroix,
Diary, 1852.

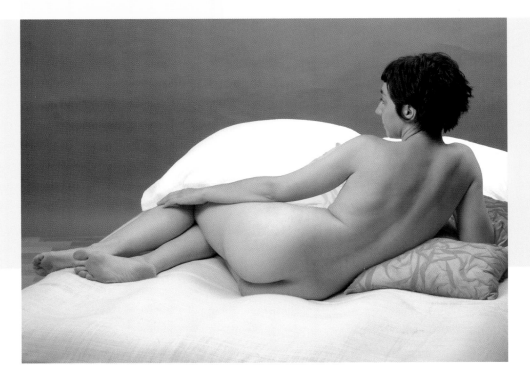

3 In this phase we establish the hue of the background using raw umber and a few touches of gray. The greenish color of the umber comes into contact with the green shadows of the figure, integrating it into the background.

1 Using a brush dipped in paint diluted with turpentine we outline the figure in warm hues that later will be integrated into the rest of the flesh tones.

2 We establish the general flesh tones using very diluted paint: pink for the reflections, slightly green for the shadows, and burnt sienna for the darkest areas. We also color in the bed with a gray applied in long, blended brush strokes and use some direct schematic strokes to define the orange of the fabric.

4 We complete the flesh tones of the model by blending the initial tones together and by adding on top of it a pale pink made from bright carmine.

5 To finish up, we intensify the dark hues of the model using burnt sienna in the warmest areas and raw umber in the grayest areas. We paint the hair using a mixture of the two umbers, and the fabric with oranges and cadmium yellows.

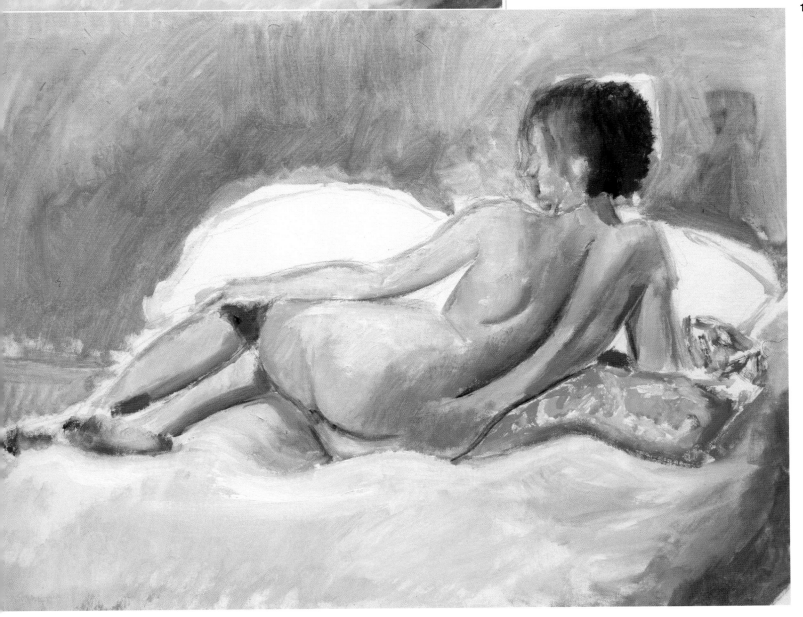

Other Results

Flesh tones commonly are shades of umber with somewhat cool shadows, but the hues of these umbers and cool tones may be very different: pink, greenish, bluish, grayish, and so forth. Sanmiguel has used these colors to create the portrait of the nude in this Gallery.

A pink color scale using burnt sienna and cadmium red plus white is the basis of this chromatic treatment. The reddish shadow at the base of the back is noteworthy; interestingly, it is luminous because, even though the value is dark, the color turns out quite pure, which sets up an intense vibration. The greenish background increases the sense of warmth in the nude body through the contrasts involving complementary colors.

In this instance, the flesh tones are very pale. A white skin reveals greenish shadows despite the warmth produced by the cream color produced by umbers and white. This effect is a result of the interaction with the background, which is very red; it converts the raw sienna color of the shadow into green through the nature of complementary colors.

Here we see a clear combination involving warm and cold colors. The figure is pink and orange in color, and the background is comprised of greenish blues. There are no contrasts or chromatic shadings in the shapes because the base color has been lightened using white in the illuminated areas without adding other colors.

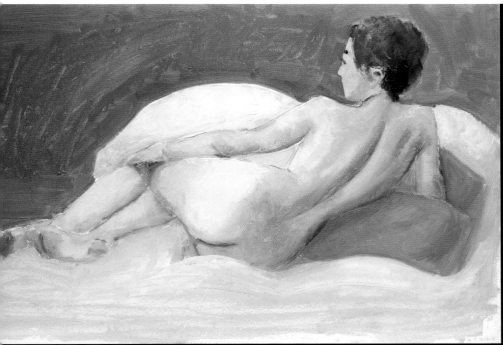

In this work the figure appears to be sculpted from marble because of the white, cool colors used on the skin. This effect is caused by the presence of blue in the burnt umber tones and the addition of white. The blue and the umber form a gray when they are mixed, which significantly dampens the chromatic tension in the color fields and gives the image a subdued appearance. The slightly bluish background helps create this climate of distance and coolness.

This model has the brownest skin tone. The presence of more luminous colors such as ochre yellow and cadmium orange in the mixtures with umbers creates a new phenomenon: a light that seems to emanate from the model. The bluish tone on the white sheet further accentuates the browning of the skin.

Other Models

A reclining figure displaying the back requires
a soft sculpting of flesh tones without strong
contrasts. In changing the pose and tackling
a different color distribution in the flesh
tones, Sanmiguel has selected a frontal,
seated pose. He has developed the flesh
tones in a color scale that combines
both raw and burnt sienna and a cobalt
violet; this combination is clearly visible
in the shadows, and it cools the dark
areas. This purplish tone in the
shadows gives the figure an appearance
of sadness.

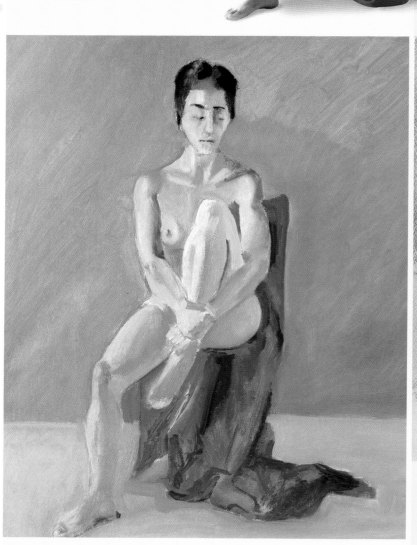

Other Media

Colored pencils allow for direct application onto the paper using decisive, freehand strokes. Creating the flesh tones with this dry medium is very different than with oils. Color fields are built up using expressive shading, and the color blending is accomplished on the spectator's retina, for the paper reveals the overlapping and hatching that the observer mixes visually according to perception. In this sketch the contrast between pinks and oranges in the skin is highly accentuated; however, this poses no problem. They integrate perfectly with one another because they are adjacent colors.

Other Views

Let's take a look at the views used by two realist painters like Freud, but with very different moods: a classicist and a romantic. Jean-Auguste-Dominique Ingres (1780–1867), a classical painter par excellence, possessed a great sense of reality and harmony. In his work he considered himself a conserver of the "good doctrines" rather than an innovator. In his estimation, the function of color was to highlight the matter contained in the picture. His forms are colored drawings rather than paintings. Marià Fortuny (1838–1874), in contrast, believed theories concerning ideal beauty were fundamentally unintelligible or pure nonsense. He rejected all academic formulas. His language was based on fresh, nervous colors created with great virtuosity. The power of light and chromatic intensity were his motivations for painting.

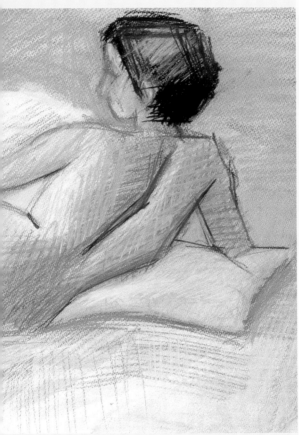

Marià Fortuny,
Nude on the Beach at Portici, 1974.
Cason del Buen Retiro, Madrid.

J. A. Dominique Ingres,
La Grande odalisque, 1814.
The Louvre, París.

Subjective, Autonomous, Instinctive Colors . .

André Derain (1880–1954), one of the masters of Fauvism, wanted to liberate painting from the seal of impressionism, with a view to representing nature in the most expressive and intense manner possible. To that end he strove to allow every painting to emanate its own light and chromatic harmony; as he stated, "I am convinced that the realistic period is over. . . . I believe that lines and colors have sufficiently powerful relationships to allow us to discover a simpler field for synthesizing them." Derain expressed himself directly though color, often applied pure, just as it came from the paint tubes; at other times he used energetic brush strokes of subjective colors that reflected his feelings. In his painting color loses its representative value; it distances itself from reference to the model and takes on an autonomy and independence, even becoming a symbolic element; it embodies the sensations and the emotions that the painting evokes, thus fusing directly with the artist's visual experience.

André Derain,
Portrait of Henri Matisse, 1905.
Tate Gallery, London.

Color Tetrads: Subjective Color Interpretation Based on a Black and White Portrait

The principle of color autonomy, ushered in by Fauvism, is the focus of the work in the following creative project. In order to avoid any influence from the model, Esther Olivé de Puig works on the basis of a black and white photograph to develop a series of full-color portraits in oils. The absence of color in the model and forced lighting are the catalysts for subjective color interpretation in the areas of light and shadow on the face. The chromatic scales the artist uses are color tetrads: four colors that form a rectangle when they are connected on the color wheel. In this case, the artist has chosen a tetrad composed of green, red, orange, and blue (two primary and two secondary colors). This choice involves two pairs of complements (red-green and blue-orange), which sets up the tensions characteristic of Fauvism and expressionism.

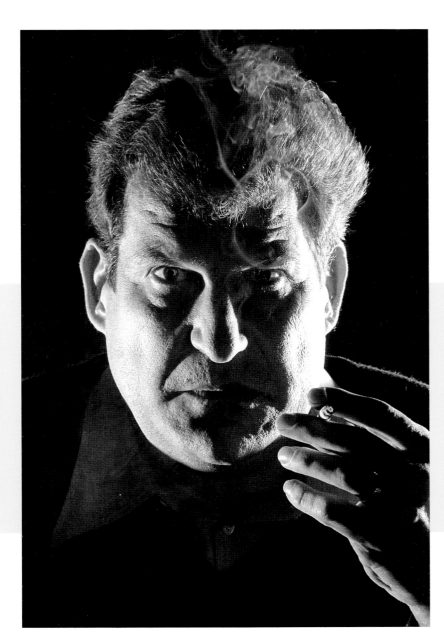

"I chose brighter tones for all my colors and transposed all the things that I felt into an orchestration of pure colors. I was a sentimental savage, filled with violence. I instinctively translated what I saw, without any method, and I transmitted truth, not so much in an artistic as in a human way."
Maurice Vlaminck

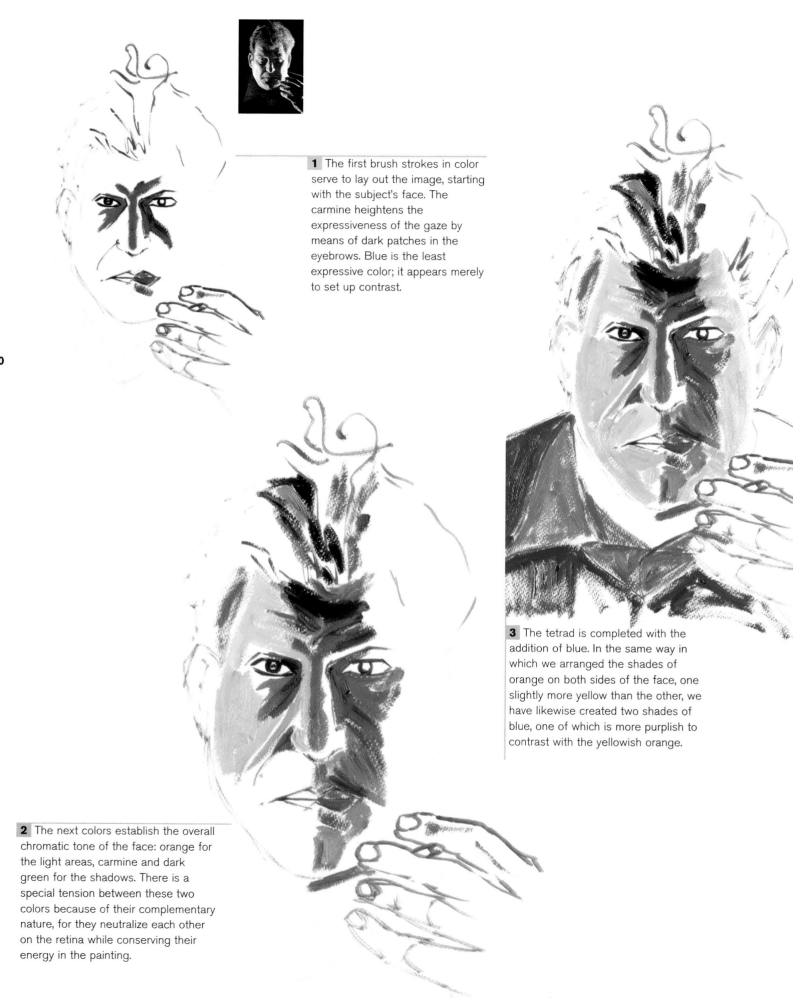

1 The first brush strokes in color serve to lay out the image, starting with the subject's face. The carmine heightens the expressiveness of the gaze by means of dark patches in the eyebrows. Blue is the least expressive color; it appears merely to set up contrast.

3 The tetrad is completed with the addition of blue. In the same way in which we arranged the shades of orange on both sides of the face, one slightly more yellow than the other, we have likewise created two shades of blue, one of which is more purplish to contrast with the yellowish orange.

2 The next colors establish the overall chromatic tone of the face: orange for the light areas, carmine and dark green for the shadows. There is a special tension between these two colors because of their complementary nature, for they neutralize each other on the retina while conserving their energy in the painting.

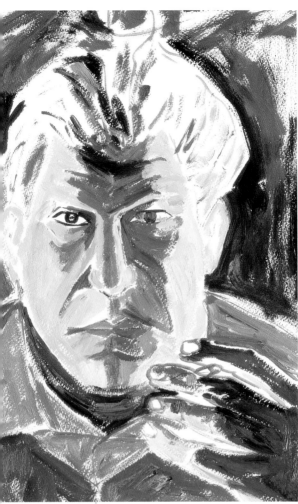

4 Next we paint the background in blue to further emphasize the orange light of the face. We also complete the figure with greens on the neck and carmine on the hand. We blend the colors of the face and sculpt the features.

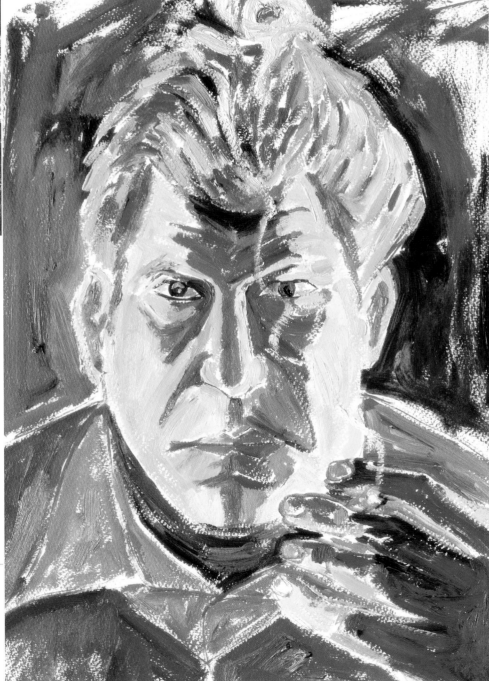

5 Finally, we paint the model's hair using the four colors of the tetrad: carmine, orange, green, and blue. In order to enhance the finished quality of the portrait, we touch up the hand, the ears, and the eyes, giving the person greater presence.

Other Results

Chromatic harmonizations through tetrads allow for a great many combinations, since the sides of the rectangle can be moved to different shades appropriate to each of the four colors. In this Gallery we look at five different combinations that involve different tones of orange, blue, red, and green.

The main tension in this portrait is set up by very pure orange and blue. A brilliant green, in combination with a bright red, is applied at specific points to force the portrait chromatically toward pure Fauvism. The most disturbing tension is created in the eyes by painting the pupils red and the eyelids green.

This more spontaneous portrait, incorporating freehand brush strokes, is the most complex one on a chromatic level, since it involves a broad scale of blues that contrast with several oranges in a direct and dynamic way.

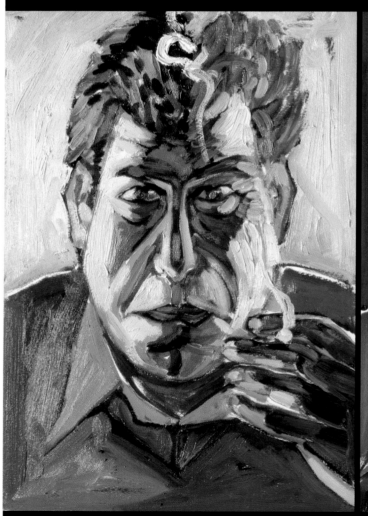

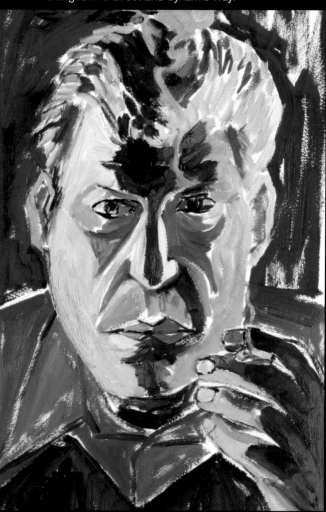

The remarkable feature of this portrait is the purity of the tones on the face and the clothing. Pure red and green in the shirt and sweater, and luminous orange and electric blue in the face are the two color pairs that recall some portraits by van Gogh.

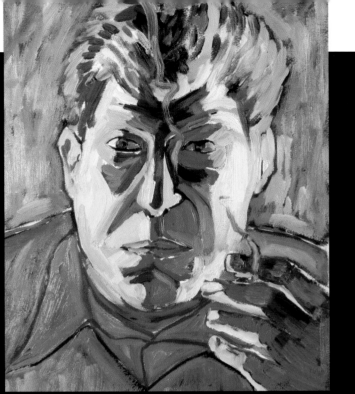

This painting establishes a luminous as well as a chromatic contrast. Working with four colors doesn't preclude the use of white and black to illuminate or darken some of them. The pastelized green of the reflections on the face, along with the blackened red in some of the shadows, produces a strongly accentuated contrast with an expressionist character.

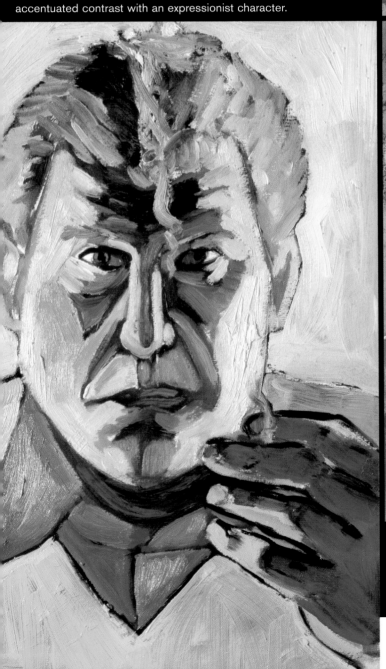

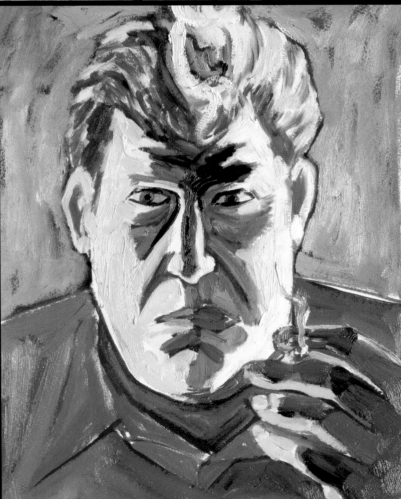

In this instance the oranges contain lots of yellow, so the tetrad has moved one of its vertices toward the very purplish blues. Recall that in a tetrad the sides of the rectangle must always be parallel. Thus the orange-blue relationship is now nearly yellow-violet.

Other Models

It is also possible to begin with color portraits, without having to invent; we can simply exaggerate certain shades in order to increase the subjectivity. To that end, Esther Olivé de Puig has started with a portrait very different from the preceding one. She has used the four colors of the tetrads mentioned earlier; however, the artist has modified the hues in order to feel the image is hers: blue in the hair and the blouse, and dark orange in the background.

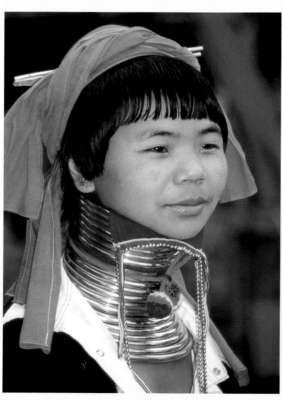

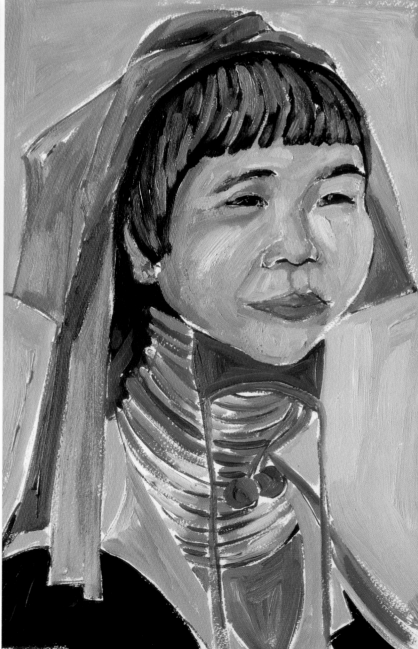

Other Media

Colored markers are better suited to drawing than to painting. The artist has chosen this medium for one simple reason: its immediacy and its direct application of color. Whereas oils allow mixing on the palette to find the right hues, markers require the straight application of colors in hatching, as when Derain painted straight out of the tube, with no mixing.

Other Views

Attracted to the world of show business, Toulouse-Lautrec (1864–1901) captured the beauty of picturesque, sometimes grotesque, people from Parisian night life with great virtuosity. As he confessed to Yvette Guilbert, "everywhere ugliness always has its beautiful side, and it is always a thrill to discover it precisely where no one expects it." The rich, free color palette of Toulouse-Lautrec is an invitation to freedom from inhibition and to optimism. In portraits such as this one the painter forces the color in a creative way by bringing us closer to a world of fantasy.

Toulouse-Lautrec,
Yvette Guilbert Singing "Linger Longer, Loo," 1894. Pushkin Museum, Moscow.

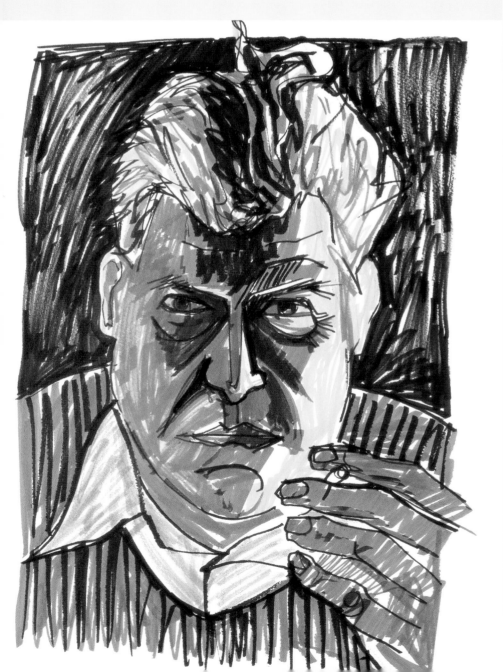

Subdued, Dramatic, *Muddy Colors . . .*

Georges-Henri Rouault (1871–1929) was considered an outstanding French impressionist artist and the most important sacred painters of the contemporary period. Critics in Paris didn't understand him; they considered his work excessively black, muddy, and decadent, but he always remained faithful to his principles, claiming, "You must follow your way, no matter how hard it may be, in order to reach the desired goal. It's better to be mistaken in following your own vocation than to falsify it by adapting to different ways." His work in stained glass influenced his paintings, for he used bright tones outlined in thick, dark lines. He felt great compassion for humans, whom he unmasked in his paintings in order to reveal their true soul: "I have seen clearly that the clown is me, is us . . . nearly all of us." With respect to color he created dissonances by joining the tragic colors of Goya, gray, black, and brown, with pure blue and red.

Georges-Henri Rouault,
De Profundis, 1946.
National Museum of Modern
Art, Paris.

Interaction
with the Color Black:
A Group Scene

When we limit the use of black to the darkening of other colors, we lose its tremendous expressive capacity and convert it into a threat, sometimes banishing it from our palette because of its great ability to sully things against our will. Even though historically black has been considered the negation of color, many pictorial movements, especially the expressionistic ones, have esteemed this color highly and integrated it fully into their vocabulary. In this project, Josep Asunción makes the most of black by causing it to interact with other colors through one concrete technique: the wash. The medium is watery and mixed: a combination of gouache and artists' inks applied with brush and cane.

"Anyone who expresses directly and openly what it is that inspires creativity is one of us."
E. L. Kirchner,
Expressionist Manifesto.

1 After laying out the various features of the picture in pencil, we apply bright, luminous colors to the main parts of the scene. We interpret the color subjectively rather than reproducing it naturally, so the sky is orange, the skin of the people lemon yellow . . .

2 We paint the ground in emerald green and use cobalt blue for the vehicle in which the people in the scene are traveling. Gouache covers very well and dries to a very flat finish. The subsequent treatment with water creates sponginess and erodes the colors.

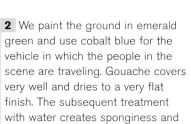

4 Once the gouache is totally dry, we begin to use India ink to paint all the areas left free of paint. There's no need to be a stickler for detail in adding these lines; on the contrary, it's appropriate to exaggerate them to create rough areas and accidental black spots that add expressiveness to the work.

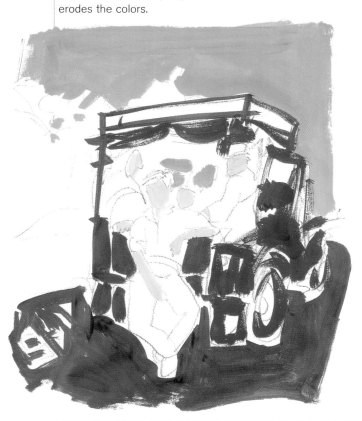

3 We conclude this first phase of the work by applying all the colors. Note that there are white areas among the colored areas. These are converted into black lines after the water treatment; if we didn't leave those areas free of paint, the black wouldn't be able to penetrate the paper and would get lost in the wash process.

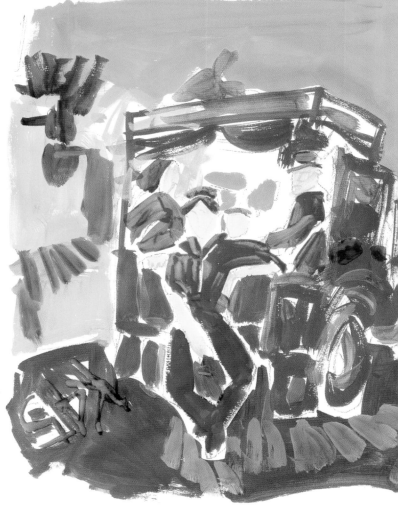

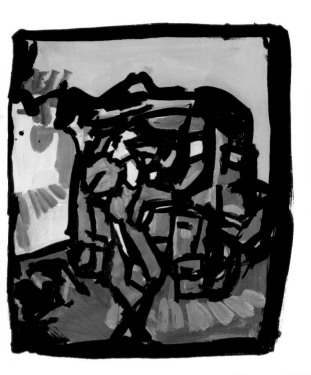

5 After a few minutes, when the India ink has dried, we wash the work with a copious stream of water under pressure to remove the black that's on top of the gouache. We can use a faucet with a spray nozzle or a plastic brush handled carefully to avoid damaging the fiber of the paper, which is very vulnerable because of the extreme wetness.

6 Once the piece of paper is dry, we move on to the final stage. We note that the water has partially washed out the colors and the drawing is very indistinct, so we decide to finish off the work using India ink, making use of the wear and the imperfections. We apply the final strokes using a cane to restore the original drawing. We also use the cane to create hatching that links the black to the rest of the colors.

Other Results

By varying the color scale of the gouache, the black areas between the colors, the degree of color erosion produced by the water wash, and the final finish with inks, we can achieve very different results with a more or less dramatic or muddy appearance, as we see in these pages.

This is the result that comes closest to the language of drawing or illustration. The wash has acted very aggressively, and as a result the colors still retain much of their initial energy. The final strokes using India ink add detail to the features and simultaneously create different planes among the people.

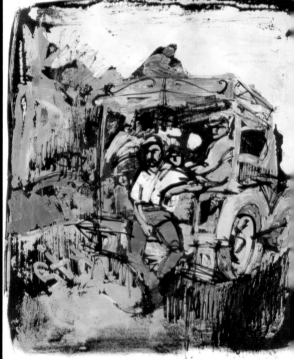

The pink produced by an intense wash on magenta gouache contrasts with the harsh, muddy blacks of the India ink. The chiaroscuro is intense, and there is no subtle chromatic effect. Here the colors work like flat areas over which the black gains ascendancy.

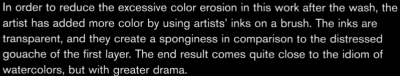

In order to reduce the excessive color erosion in this work after the wash, the artist has added more color by using artists' inks on a brush. The inks are transparent, and they create a sponginess in comparison to the distressed gouache of the first layer. The end result comes quite close to the idiom of watercolors, but with greater drama.

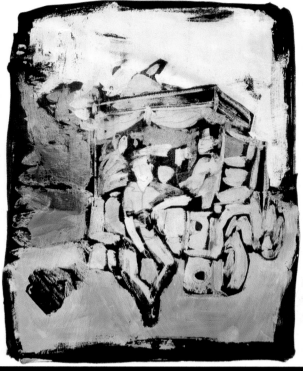

In this instance the artist chose not to proceed beyond the wash, for the picture was already deemed to be sufficiently attractive and suggestive at this juncture. The wash was quite aggressive, and it was reinforced with a brush in order to tear into the blacks and bleach out the colors, which gives the work an appearance of increased erosion.

This work is characterized by a warm atmosphere produced by a large orange glaze created with artists' ink applied to the final result. The colors are turbid, and they temper one another in wet and ambient appearance. The final appearance recalls some old documentary photographs colored by hand in order to subtract drama from the original sepia tone.

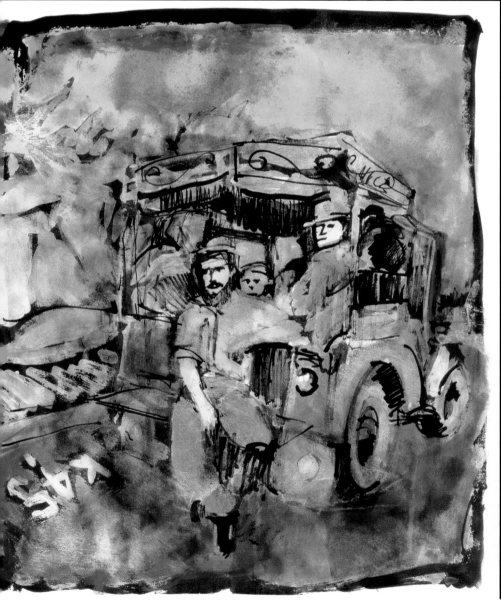

This work is the muddiest and most dramatic one in the Gallery. The wash has been used very forcefully in order to blur the original image as much as possible and create a greater sense of mystery. A couple of final glazings of wine-colored artists' ink and some very energetic black lines serve to partially restore the image.

New Projects

Other Models

In order to inspire subjective colors in combination with black, the artist has resorted to using the negative of a color photograph. The negative completely changes the natural colors by bringing out their complements. In this instance the model is the photograph of a concert. In the negative the singers, who are illuminated by a yellow spotlight, appear totally bathed in blue.

Other Media

Shading in a dry medium is very different from a wash in an aqueous medium; in this picture the artist has opted for the former. We now show the same work done in colored chalks in two phases that work perfectly independently from one another. There is a different level of black in each one. Note how the drama increases in proportion to the quantity of black, yet the black doesn't muddy the work, since it has been worked as a color itself in an expressionist manner.

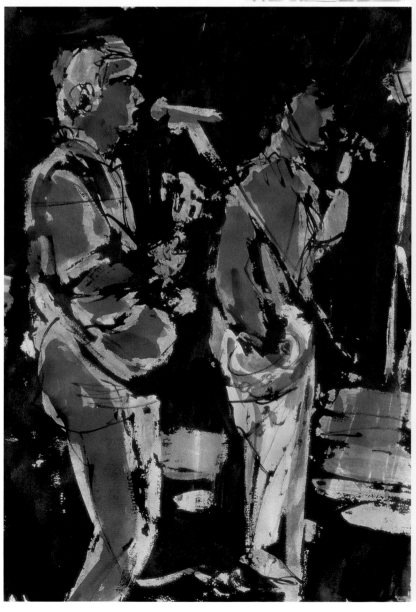

Other Views

In 1823 Goya (1789–1828) concluded his black paintings, which were done in oils on the plastered walls of his house, the Quinta del Sordo, and subsequently transferred to canvas. In these mural paintings he demonstrated a liberty surprising for the time and an attitude that opened the doors for other vanguard painters of the twentieth century. The German expressionists of Die Brücke considered him the true father of expressionism, not only for the formal appearance of his works, but also because he displays in them the tragedy of human existence and an antipathy to bland aesthetic painting.

Francisco de Goya,
Pilgrimage to San Isidro, 1820–1823 (detail).
The Prado, Madrid.

In abstract art, color occupies a privileged place because it can function autonomously as a pure sensation, without being subjected to the conditions of the object represented (the green of a field, the yellow of the sun, the pink of the flesh . . .). In this chapter we propose two creative projects that demonstrate two different aspects of the use of color in abstraction: the creation of all-encompassing chromatic moods and geometrical compositions composed of flat color planes.

Color in

Abstract Art

"Abstraction involves transposing (transmuting) the observed phenomenon into simpler, clearer, more evocative final terms in an organic way. Since the intrinsic nature of art is abstraction, it is simply logical to pursue abstraction fearlessly to its logical goal . . . : abstraction as an idiomatic figure opens the unconscious mind and allows the truth to emerge."
John Graham,
1937.

Enveloping, Atmospheric, Spatial Colors

Mark Rothko (1903–1970) was absorbed by painting as a prophetic and moral way of life, believing "the most revolutionary act consists of painting in a way true to oneself." With other abstract expressionists he shared the belief that the canvas is a field of action. Even his earliest paintings evoke expressive, light, ethereal, and spiritual sensations, but it was through abstraction that he liberated his art of anything anecdotal or superfluous. His abstract forms transfer us to a pictorial representation of emptiness, nothingness: simple but dramatic shapes that grow freely within the canvas without being limited by outlines, becoming transformed into pure color. His work evolved into nebulous bands and rectangles of color that capture states of mind or emotional excitement more than specific feelings or concrete responses.

Mark Rothko,
Orange, Red, and Red, 1962.
Dallas Museum of Art.

Chromatic Expressiveness: Abstraction Based on Inner Space

Atmospheric painting emphasizes the perceptual characteristics of air: density, moistness, filtered light, lack of visual clarity . . . In abstract art, these characteristics act on the observers as if they were plunged into the painting, soaked up into the colors in a pure state in a soft, pasty, pictorial haze. The artist in this creative project, Gemma Guasch, presents a series of paintings based on the color sensations suggested by an empty indoor space. The medium used is acrylics on canvas, applied with a brush, sponges, and roller. The results of her work remind us of the vision we experience when we close our eyes after exposing them to the light: abstract fields of color that blend together in continuous movement.

"Imagining or conceiving a composition of forms or a particular color scale in any given rectangle is not a question of mediums, but rather an inner spiritual vision."
Max Weber,
Essays on Art,
1916.

1 We begin with a colored background that combines areas of bright carmine and dark cadmium. That establishes the general color tone of the work, where red is the predominant color in the atmosphere.

4 Using a thick brush we add lines in permanent green orange and cadmium red once again. The consistency of the paint should not be pasty, but rather dilute, so that as the colors are spread out they allow the layers beneath to show through.

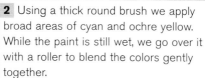

2 Using a thick round brush we apply broad areas of cyan and ochre yellow. While the paint is still wet, we go over it with a roller to blend the colors gently together.

3 We have to control the use of the roller and calculate the number of passes. In the center, for example, we have done several passes to blend the yellow into a dense haze; however, in the blues the atmosphere is not as uniform because the brush strokes of cyan over the ochre left many places uncovered and we have limited the use of the roller.

5 We use the roller on the preceding layer to spread the colors out. We do this step several times, creating new hues with every pass. In the last layer we apply a new technique: a soft blending with a badger brush. The last colors are applied more thickly and cut with white to create reflections, and we pass the badger brush gently over these areas to blend in the colors.

6 The final result contains some touches of white that keep the painting from falling into an unwanted tenebrism. The restoration of the cadmium red restores the general hue of the atmosphere (red); it is applied over the previous layer and blended in with the badger brush.

An empty space can make us perceive quite a number of different sensations. We can transform these sensations into different color combinations, which is what Gemma Guasch has intended in the following treatments.

We create a dramatic, intense effect through a combination of warm hues saturated with red, yellow, and orange combined with black. The red is blended in with the other warm colors, but it doesn't mix with the black; this allows the red to retain its own light and remain apart from the muddy colors that would obscure the overall chromatic effect.

The austerity of colors is enough to envelop us in a sweet, welcoming atmosphere. The richness of the combination of yellow and red comes from the subtle hues achieved with each color and the work previously done on the canvas. Underneath these colors are several layers of dark hues that endow the red and yellow with a certain sponginess.

The color sensation achieved is subtle and warm. The cadmium red is the main feature of this result; it provides the work with luminous intensity. In the lower part we find umbers, and in the upper a white broken up with subtle blue shades provides a delicate contrast.

Color combinations like this one give us a sensation of positivism and ingenuousness. The ultramarine blue and the orange provide light and contrast. The orange hue bathes the surface of the painting without smothering the grayish green and the red that enter timidly from behind. Finally, a light touch of permanent green emphasizes the vivacity of the whole.

A furious orange combined with several colors causes a sensation of dynamism, openness, and freshness. The orange is used pure, without mixing; the blues and yellows, in contrast, are mixed with white in unequal proportions to allow the creation of a more enveloping and atmospheric effect.

We are filled with melancholy and sadness when we contemplate the different neutralized hues: grays, blues, and purples. The red brush stroke contributes the luminous contrast that the painting needs. The subdued tones of purplish gray and bluish gray add special depth by locating the observer in front of the emptiness of the *void*.

Other Models

The long walkway that surrounds the cloister of a monastery is the other model selected by the artist, a space filled with living history where the union between the exterior (landscape) and the interior (residence) is direct, with nothing in between. The arches and the stones contribute majesty, grandness, and warmth. The color sensation that's achieved is elegant and conservative, based on blues and umbers. Some whites applied to highlight the verticality suggest a filtered light that connects the sky and the earth.

Other Media

In this instance Gemma Guasch has chosen pastels. The sticks of pastel are soft and make it easier to blend tones without using other tools. The pad of the fingers or a piece of cotton can be used to spread out the colors and blend them together, easily creating atmospheric and enveloping effects. Finally, we apply more energetic strokes that favor contrast and give the whole more vigor. It's important to avoid abusing the effect we achieve in fusing the various hues because we could darken and sully the colors.

Other Views

José Manuel Broto (born 1949), an inheritor of lyrical abstraction who has been influenced by the browns and blacks of Tàpies, produces and suggests explosive, deep, atmospheric paintings that awaken countless emotions. Broto brings back the color fields of Rothko and combines them with shapes that suggest landscapes. The color fields of Per Kirkeby (born 1938), in contrast, surround us in an atmosphere that's more expressionistic than lyrical. Because of the thick, energetic strokes of a controlled automatism, the color sensations are strong and direct: the color is more material than ethereal, and it seems to color us physically in a very dense atmosphere.

Per Kirkeby,
Laese, 1992.
Michael Werner Gallery,
Cologne, Germany.

José Manuel Broto,
Sefarad XII, 1994.
Private collection.

Flat, Superficial, Juxtaposed Colors . . .

Robert Delaunay (1885–1941) was a precursor of the artistic movement known as *Orphism* or *Orphic cubism*. He was strongly influenced by Gauguin and the Pont Avent school. His first works were neoimpressionistic and pointillist, based on the divisionism principles of Signac and Seurat, but at the time his real interest was color, which gradually became a permanent obsession throughout his artistic career. Working on the theory of simultaneous color contrasts of the scientist Chevreul, and with his background as a divisionist painter, Delaunay's Orphism contributed great dynamism to cubism through the explosive use of colors. His painting was based on light as a principle of energy or vital force, without capturing it inside shapes. In his abstract images the active subject is pure color, with absolutely no reference to reality. Through color combinations in colored circles and planes he showed color in its pure state and in a dynamic way, like a living element.

Creative Project 15

Robert Delaunay,
Endless Rhythm, 1934.
Museum of Modern Art,
Paris.

Fields of Color: Chromatic Organization in Fractals

In approaching an abstract color composition we have chosen a model based on a fractal. This image is generated using a mathematical analysis of natural systems in which there is no clear geometrical logic. Fractals are characterized by a repetition of similar parts in a global whole that is likewise similar to its parts. In this work, Josep Asunción has begun with warm and cool colors arranged in circular color fields. The medium used is watercolor on paper. The artist has used the fractal solely as inspiration and has done a series of watercolors of different shapes and colors in the same scale of flat, superficial, luminous tones, as in the original fractal.

"Color is shape and subject, it is the only subject that is developed and transformed by itself, independently of any analysis, whether psychological or not. Color is a function of itself . . ."
Robert Delaunay

1 After attaching the paper to an easel with cellophane tape to keep it from deforming with the moisture, we locate the first colors of the composition; later these will be treated with glazing. The broad wet strokes are done using a flat broad brush with very soft bristles.

2 The following brush strokes are in orange applied over the blue base. Here we are working in two different rhythms to create distinct effects. First, we paint the new color over the base when the base is totally dry so the colors don't run together, and to produce a perfect glazing; second, we work on one of the orange circles while it's still damp to create a spongy effect with indistinct edges.

3 We use a rag to blot excess moisture from the circle we painted wet over wet. This action produces a very special atmospheric, luminous effect. Next we draw stripes in very luminous yellow, orange, and green tones to create clean glazing.

4 Using a moist sponge we rub the painted surface to make the oranges and greens mix together. The sponge creates a series of indistinct, rough edges that help create atmosphere and density. A small very dark Prussian blue circle serves as a chromatic counterpoint and keeps the composition from ending up too pale.

5 Once again we use a moist sponge to rub part of the surface, this time erasing and blending the color in the center of the composition to create an area of light. When the paper is perfectly dry we paint some new brightly colored circles in red and orange. These last circles contribute neatness and luminosity to the watercolor.

Other Results

By combining colors in circular structures in different ways, the artist has achieved various chromatic effects without betraying the initial idea inspired by fractals: circular fields of warm and cool colors. All the results have in common the cleanliness of color, glazing, and flat colors.

In this painting the artist has alternated warm and cool circles inside one another, but in a gentle way, without undue stridency, in an overall tone of light and transparency. No glazing has been used; rather the artist worked slowly and with attention to detail, waiting for the paints to dry and allowing each one to touch the previous one at the edges without invading its territory.

We have created a blue glazing on a base in which the warm color fields are organized in concentric patterns with more luminous hues arranged in the center and the darker ones toward the outside so the warm colors show through the blue.

This delicate watercolor is the result of combining several techniques: concentric circles drawn and allowed to dry in order to keep the colors from mixing together; glazing in soft colors; and applying the sponge while the colors are wet to mix them on the paper and create an atmospheric appearance.

We have done this watercolor in two phases. In the first, we established the base colors using cool neutral colors. In the second, we created a new chromatic structure that lets the previous one show through, this time using warm colors.

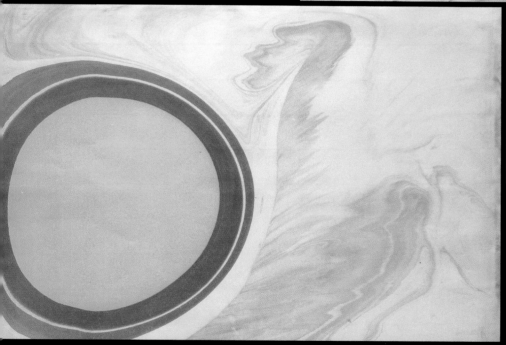

The first phase of this work involves a complete image of small concentric circles in the center arranged on a large pink surface and a line set aside by using a mask. In a second phase we removed the mask and applied a large glazing in deep red that covers nearly the whole composition and leaves an empty spot in the middle.

The main focus of this composition is the pure yellow of the circle. The outside of this color field is the same color as the paper with a few touches of pale orange. The edges of the yellow circle follow a concentric rhythm, suggesting the work of Delaunay, as if this were a colored moon.

Other Models

The fractal we have selected for producing other variants is an image of blue colors combined with cream colors in a soft harmonization that break the touches of bright reds and yellows in only certain points. In this instance, the artist has reduced these touches of intense color to two yellow circles in blue and cream waters. A final glazing in a darker blue covers the edges of the work, producing a greater chromatic sensation of space, which is appropriate to all fractals.

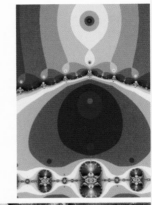

Other Media

In order to vary the medium and experiment with very different results, the artist chose to go to the opposite pole of watercolors and applied acrylics densely on to coarse wooden tablets. This is as far removed as possible from the transparency of watercolors and the lightness of paper. Since the medium is very

different, as is the support, the result is truly novel. The color fields remain superficial and flat, but not as luminous because the medium lacks transparency and the paint takes on an appearance of substance that can't be achieved with watercolors.

Other Views

Working in the abstract with flat colors as the main focus always involves choosing a personal harmonization. Every artist has an individual color palette and is used to moving among the colors appropriated into a personal idiom. Let's look at two contemporary artists who create based on abstraction by using personal palettes, both dynamic and involving bright colors. Caroll Dunham (born 1949) uses very artificial hues, and Charo Pradas (born 1960) uses a scale of luminous colors that recalls the scales used in some textile prints. These involve very contemporary harmonizations that express today's relationships between painting and graphic design or graffiti.

Charo Pradas,
If-then, 6, 1995.
Private collection.

Caroll Dunham,
Visible Language, 1994.
Sonnabend Gallery,
New York.

These are the media composed of a mix of pigment, agglutinant, and a diluent. Depending on the diluent used, they are classified into two groups: oil and water.

The following pages describe the basic concepts related to media, support surfaces, applicators, and the techniques used in the creative projects in this book.

OILY MEDIA

Essences are the diluents used in oily media. There are plant and mineral essences. The plant essences are essence of turpentine, which is more refined, and turpentine, which is coarser. Mineral essence produced from petroleum is similar and can be substituted for turpentine.

Oil

This is one of the most highly regarded media in the history of painting. In consistency it is thick and oily; it is made up of tints or pigments mixed with an agglutinant such as linseed, nut, or poppy oil. It is best diluted with a plant essence: turpentine or essence of turpentine. It is available on the market in different sized tubes (from 5 to 200 ml) or in jars (1 kg). The prices vary widely depending on the initial cost of the pigment; the shades of umber are the most economical ones, and the cadmium paints may cost four times as much. Nowadays cheaper lines have replaced natural pigments with synthetic ones. Oil paints dry very slowly; this makes it possible to blend colors and retouch shapes, providing more time to work on the painting. The hues are vivid and intense, and they don't lose much of their brilliance when they dry. This medium is recommended for use on canvas, wood, and hard cardboard supports. The best brushes are made with boar's or similar bristles; for impastos it's appropriate to use a palette knife.

Waxes

These are the product of mixing pure pigment with animal fats and waxes; they are sold in sticks of different colors. They produce thick buttery lines. The colors are intense and brilliant. They can be mixed on the support by pressing the various colors with a piece of cotton, a paper towel, or an eraser, or with the fingers, producing a smooth, shiny, and greasy texture. We can also dilute the colors with a brush or a piece of paper towel dipped in essence of turpentine or turpentine to produce a transparent effect. This is an ideal medium for the graffito technique, which involves using a sharp implement (e.g., a razor blade or a hobby knife) to scrape the colors previously applied to a surface, thereby producing very special shapes and textures.

This is also a very good medium for setting aside reserves: first the wax colors are used to create a

Wax Sticks

drawing or apply color to the paper; then paint or ink is applied over it. Since the wax repels all aqueous media, the area treated with wax is a reserve. Waxes are sold in boxes containing different colors, or individually, at very reasonable prices. The best supports are on paper and cardboard. It's a good idea to fix finished works using lacquer or fixative.

Oil Paints

AQUEOUS MEDIA

Tap water or distilled water is the diluent of these media, which do not produce a grainy texture.

Acrylics

Acrylics are made from pigments agglutinated with synthetic resins. They are characterized by rapid drying and resistance to yellowing with the passage of time. They are very versatile; they offer the possibilities of watercolors when diluted with plenty of water and of oil impastos if used without water. They are soft and creamy in consistency, very similar to oils, and ideal for impastos. Acrylics are diluted with water or with an acrylic medium. The drying process can be slowed down by adding glycerin or a retarding medium. Acrylic paints provide a matte, uniform finish, but we can restore the gloss by applying a thin transparent layer of acrylic varnish. Acrylics are sold at reasonable prices in different size tubes or in jars. This is a very durable medium that can be used with any applicator and on most supports.

Acrylic Paints

Watercolors

Watercolors are comprised of finely ground pigments without much covering power mixed with gum Arabic as an agglutinant, to which some other substance such as honey is added to give it plasticity. Watercolors are available in tablets or tubes of different sizes, and they are available in boxes of different colors or individually.

Tablets of Watercolors

Their main characteristic is their transparency. When we mix the pigment with water we reduce the intensity of the tone and increase the transparency and luminosity. There is no white watercolor, so that color is produced by setting aside the white of the paper or by using an opaque water-based paint such as white gouache over the watercolor.

Because of their softness, brushes made with marten hair are ideal for watercolors, but nowadays synthetic brushes yield similar results and are more economical. We can apply washes using a sponge, a roller, or a paper towel. Watercolor paper is the ideal support; it is available in different weights and textures. It can be worked dry or wet; in the latter case it must first be stretched on a wooden easel using cellophane tape.

Inks

These may be either soluble or nonsoluble in water. Nonwater soluble inks contain lacquer. They are denser and dry to a glossy finish. Water-soluble inks contain no lacquer and are used for line drawings or hatching applied with nibs or cane, and for washes applied with a brush. When they dry they produce a matte finish because they penetrate deeper into the paper. They are sold in different tones, but black is the one most commonly used.

Inks can be diluted with tap water or distilled water.

Artists' Inks

Inks are the ideal medium for mixing with other media and producing very special effects.

It's preferable to apply inks using round brushes because they are better at picking up the water. To produce effects of drawing, the inks can be applied with a nib or a cane. There are nibs of different sizes in the marketplace that produce fine or thick lines. The cane is the most primitive and rustic, for it produces more irregular and expressive lines. Smooth or satiny paper with a certain hardness is a good choice for a support.

Gouache

Gouache

This is also known by the name tempera or gum tempera or opaque water paint. This paint is diluted with water and made up of pigment and gum Arabic. Like watercolors, gouache is applied to paper, but it is a thicker medium, and thus it covers more effectively. This opacity makes it possible to apply it to dark papers. It is applied in creamy form using a brush or a roller, without impastos or glazing; as a result, once it's dry the colors appear flat, uniform, and bright. This finish makes it an ideal medium for posters, illustrations, and background for other media. Gouache is sold in tubes and bottles.

These are the media that normally are applied using no diluent. They may be monochrome or polychrome.

MONOCHROME MEDIA

These are media of a single color, which is degraded to produce a broad range of luminous values.

Charcoal

This is available as sticks of grapevine, beech, or willow carbonized at a high temperature in a hermetically sealed furnace. Charcoal is sold in boxes containing several sticks about six inches (15 cm) long and in different degrees of hardness and diameters. The softest charcoal is used for shading and blending; the hardest is ideal for drawing lines and details. This is a very fragile medium, so it's a good idea to use it cut into smaller pieces. You can create different shades of gray by spreading it out with your hand or a rag. It must be used on grained or laid paper. To finish a drawing a fixative or lacquer must always be applied to preserve it.

Charcoal

Graphite Pencil

Made in the shape of very thin sticks for pencil leads, and with a greater or lesser proportion of hardener (clay) at the time of manufacturing to produce a degree of hardness or softness. Standards have been established and adopted universally to distinguish among the various degrees of hardness. The letter B is used for soft leads and H for hard, preceded by a number or a coefficient. Hard leads run from 9H (the hardest) to H, and the soft ones from 9B (the softest) to B. The grades HB and F are halfway between the two previous ones. Soft leads produce darker shades than the hard ones, so they are ideal for shading and blending, producing expressive results.

Hard pencils are more appropriate for technical drawing, since they produce precise lines and details, and their shades are lighter. In general several degrees of hardness are used in a single work, thus achieving a variety of shade and expressiveness.

Paper is the universal support; the weight, texture, and shade are chosen as a function of the effects we hope to produce, but usually graphite can be used on any paper except coated or high-gloss ones. It's a good idea to apply a fixative or lacquer when the work is considered to be finished, especially if particularly soft pencils were used.

Sanguine

Sanguine

This is a brownish chalk made from hematite (an iron mineral) that has its own personality. A single color produces a broad spectrum of reddish shades. It can be used to create fine shading by rubbing it with a rag or with the fingers to produce softer and more luminous effects than with charcoal. By using an eraser aggressively we can create watercolor-like effects. This medium can also be combined with other procedures for illustrating (e.g., pastels, charcoal, and graphite). The best paper for this medium has a little grain or texture. A fixative or lacquer must be applied once the work is finished.

Graphite Pencils

POLYCHROME MEDIA

Even though these media can be used in monochrome, they are commonly used in color combinations because of the wide variety of tones available.

Colored
Pencils

Pastels

These are made from pure pigment mixed with a plaster base and an agglutinant. They are mixed together to form a stiff paste that later is cut and molded into stick shape and set aside to harden.

There are soft and hard pastels. Soft pastels contain more pigment and less agglutinant, which makes them easy to break. They produce wonderful, brilliant, saturated, velvety hues that are ideal for blending and shading.

Hard pastels contain less pigment and more agglutinant.

Hard pastels can be used for laying out a preliminary sketch and for a final finish and details. In any case, they are an ideal complement to soft pastels.

Pastels are a very attractive and versatile medium that make it possible to produce lines, glazing, impastos, blending, and shading. An artist can work with the side of the stick, the point, or the dust that flakes off the sticks, spreading it out with a brush, the fingers, or a piece of cotton. Pastels must be applied to rough grounds or ones with large

Pastel Sticks

pores to hold the color, and on tough papers that allow working, shading, correcting, and producing effects with an eraser.

When the work is done a fixative or lacquer must be applied.

Colored Pencils

Made from pigments agglutinated with kaolin and mixed with wax, their main characteristic is their immediacy and ease of use. They are used in the same way as graphite pencils, but they produce a less oily finish that's softer and satiny. They are ideal for works in small format. They are available in boxes of different sizes and at widely varying prices. The quality of the pencils depends on the quality and quantity of the pigment used. High-quality colored pencils cover more effectively. It is possible to produce different intensities of shade by varying the pressure on the pencils. Colors can also be mixed by superimposing shaded areas. Some are watercolorable and can produce lines that can be diluted with water. Paper is the ideal support.

Chalks

Chalks are the harder pastels. Their composition is similar to that of the pastels: pigment plus glue, but they are normally hardened with resin. The most common chalks are white, black, sanguine, and sepia, but a great variety of colors are available in the marketplace. The finish produced by chalks is very graphic because they are applied in hatching and shaded areas on paper. They can also be used on fine fabrics with no printing because of their porosity, but this is no longer

common. Once the work is finished it needs to be fixed with lacquer or a fixative.

Chalks

Markers

Even though the substance that provides the color in markers is liquid (an ink that's usually soluble in alcohol), these can be characterized as dry media, since they are applied straight to the surface using no diluent. With a marker the color is transferred to the surface through a fiber tip that must always remain damp, so it's a good idea to avoid leaving the markers uncapped for very long. The most common surface for markers is paper, and shading is the technique most frequently used.

Colored
Markers

SUPPORTS

Panels
with
Cloth

Wood

Wood is appropriate for nearly all media. It has to be prepared for the desired medium. First choose the wood, which must be seasoned, free of sap, knots, and nails. It's best if it's not overly smooth. Then prepare it, neither too much nor too little, for both extremes make it harder to form a bond between the paint and the surface, producing a fragile final product that's hard to keep in good condition. Adjust the porosity of the wood with the right preparation. Various materials can be used, depending on the painting process: gesso, casein, rabbit skin glue, straight latex, or latex thinned with water. To keep the sheet from warping, prepare both sides.

Boards and Panels with Cloth

This is a cotton fabric with an acrylic primer mounted on a rigid backer. There are many standard sizes and a variety of textures. They are light and easy to transport.

Canvases

Traditionally canvases are made from plant fibers: flax, hemp, jute, or cotton. When the canvas is very coarse it is called hessian. The canvas has to be treated to reduce absorption, but without overdoing so it loses flexibility, for too strong a preparation would cause the paint to crack. Thus we prepare the canvas with a primer. Canvases are sold commercially in rolls and appropriately primed or mounted on stretchers of various types, sizes, and formats. The numbering on the stretchers is international, and each number corresponds to a certain length and width.

Paper

Paper is made up of a series of interlocking plant fibers. Nowadays the fiber comes from cellulose. The best kind comes from cotton, followed by the paper that comes from the eucalyptus or the pine (Kraft paper), which are wood fibers that deteriorate more easily with the passage of time. Ideal papers are available for wet techniques and dry techniques, which each brand sells under different names: Ingres, Canson, Torreón, Basik, Arches, and others. Colored card stock is also frequently used.

Papers

Preparing a
Board

Canvases

APPLICATORS

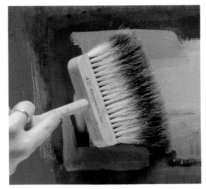

Badger Brush

Brush

A brush is composed of three parts: the bristles, the ferrule, and the handle. Brushes come in various shapes and sizes. The choice of a brush depends on the medium selected for the project. Brushes come with fine or stiff bristles, and in each category there are flat ones, round ones, and other shapes (filberts, sash brushes, fan brushes, etc.). Brushes in each group are numbered according to size. The bristles of fine brushes are made of marten, ox, nutria, squirrel, and badger hair, the latter used for the smoothest blending.

The bristles of stiff brushes are boar's bristles from pigs or wild boar. There are also brushes made with artificial fibers. Round brushes usually are made with fine bristles. They are the best for aqueous media, since they hold water more effectively. The highest quality brushes end in a point. Flat brushes tend to have stiff bristles. They are the best choice for oily media.

Brushes

Palette Knives

Palette Knives

Applicators in the shape of a knife or a spatula. They are ideal for applying impastos and mixing colors.

Sponges

Sponge

A sponge is ideal for applying washes and glazing with wet media. A sponge can be used to add or remove paint, plus moisten the paper before using it.

Small pieces of sponge adapt to the size of the hand, enabling greater precision and security. Sponges may be stiff or soft. The stiff ones produce textured surfaces; the soft ones, smooth surfaces. Sponge rollers can be used to cover large areas evenly and create expressive effects.

Cane

Sponge Roller

Cane

This is cut from bamboo or reed. It's a very primitive applicator that artists can fashion themselves. It produces irregular lines of inconsistent width.

Cotton Rags

These are required for any type of work. They can be used to blot or blend a dry medium, for they remove an excess of dust without harming the support. With wet media they help control excess water from the support and the brushes.

Techniques

A technique is the way a medium is used or a material is manipulated to achieve a specific artistic effect, even though the term technique *has often been used as a synonym of* medium.

Blending

This is the action of smoothing out a patch of color to blend its edges with the background or an adjacent color, eliminating the marks left by the applicator.

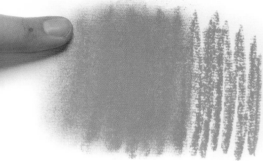

Blending

Shading

This is an artistic mixing done directly on the support while the medium is still wet.

Shading

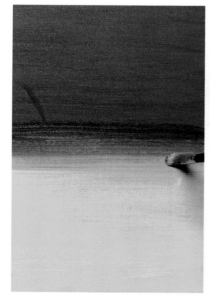

Impasto

This involves applying great quantities of thick paint with a palette knife or a stiff brush to impart depth to the surface of the painting.

Impasto

Neutralization

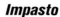
Neutralization

A neutralized color is turned to gray and darkened. Neutralization occurs when the complement of any color (the color opposite it on the color wheel) is mixed with it.

Water Wash

Water Wash

This involves applying water to a painting to remove part or all of the paint on the surface and give the image an appearance of erosion. This works only with aqueous media (watercolors, gouache, inks, and acrylics), since water acts as a diluent. The water is applied directly on to the paint or with a sponge or a large brush. Depending on the pressure and the amount of water, plus the drying stage of the work, the result is greater or lesser erosion.

Tinting

Velatura

(more commonly called "Glazing")
A transparent or semitransparent
color applied over all or part of
another color to modify its shade or
value.

Glazing

Wash

An artistic image created by applying
very diluted paint with broad
applicators, without focusing on
details.

Wash

Tinting

Tinting involves modifying a color by
mixing it with an adjacent color, that
is, one of its neighbors on the color
wheel, such as going from yellow to
orange, from blue to violet, and so
forth.

Optical Mixing

Optical Mixing

This is the optical effect produced
when the chromatic mix takes place
in the spectator's eye rather than on
the palette. This is also referred to
as the "Bezold effect" in honor of its
discoverer, or "retinal mixing." To
produce this effect, the colors have
to be applied directly on to the
canvas using small strokes or
closely packed dots (a technique
known as pointillism).

Rubbing Back

This is an artistic effect produced by
using a brush, rag, or other
applicator to rub paint that's still wet
to carry away or remove part of the
paint and let the layer beneath show
through.

Rubbing Back

Hatching

This is a technique that produces
fields of color by means of parallel
lines superimposed in a fine mesh
pattern. Depending on the distance
between the lines and the number of
overlying patterns, fairly dark colors
can be produced. If different colored
hatchings are superimposed an
optical mix is created, and the eye
perceives a mesh of the color
produced by the mixture.

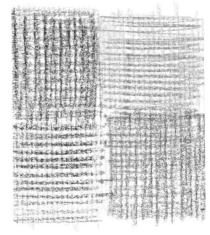

Hatching

CREATIVE
PAINTING

FORM
COLOR
SPACE
LINE

FORM
CREATIVE PAINTING

COLOR
CREATIVE PAINTING

SPACE
CREATIVE PAINTING

LINE
CREATIVE PAINTING

COI